WTF, Evolution?!

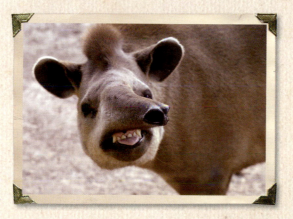

A THEORY OF UNINTELLIGIBLE DESIGN

Mara Grunbaum

WORKMAN PUBLISHING · NEW YORK

Published simultaneously in Canada by Thomas Allen & Son Limited.

Library of Congress Cataloging-in-Publication Data is available.

ISBN 978-0-7611-8034-0

This is a work of partial fiction. Any resemblance to actual natural processes is coincidental (although probably not as coincidental as you think). Species names, biological characteristics, and geological incidents are all true, except for the ones that are obviously made up. Evolution is not actually a sentient being—but it is very, very strange.

Design by Becky Terhune

Front and back cover photos: M. Woike/age fotostock
Additional photo credits appear on page 264.

Workman books are available at special discounts when purchased in bulk for premiums and sales promotions as well as for fund-raising or educational use. Special editions or book excerpts also can be created to specification. For details, contact the Special Sales Director at the address below, or send an email to specialmarkets@workman.com.

Workman Publishing Company, Inc.
225 Varick Street
New York, NY 10014-4381
workman.com

WORKMAN is a registered trademark of Workman Publishing Co., Inc.

Printed in China

First printing September 2014

10 9 8 7 6 5 4 3 2 1

For Sasha, the evolutionary
pinnacle of sisters.
I'm glad there were enough
good genes left to make you.

Contents

Introduction

Sometimes Evolution produces wonders: plants and animals so breathtakingly beautiful, so spectacularly well formed, so gracefully adapted to their own particular habitats, that you can't help but marvel at the infinite splendor of nature. But other times—well, let's just say that *splendor* may not be quite the right word for it.

Look, here's the thing about Evolution: It means well, but it's not exactly thinking everything through. People often assume that Evolution has some intention—that organisms turned out the way they did for a reason or in accordance with some gradual improvement plan. But it doesn't really work that way. In reality, Evolution is more like your generally agreeable but somewhat oblivious high school buddy, plodding along with no particular goal in mind. Like the rest of us, it's basically just fumbling in the dark.

There's no inherent logic to most of the things that Evolution does. It never stops to ask itself, what would be the *smartest* self-defense tactic I could give this newt? What's the *simplest* method of reproduction this kangaroo could use? Does this fish even look like a fish? Instead, it tries out all sorts of half-baked or ill-advised or completely ridiculous

ideas until something finally sticks—and when it does, it isn't always pretty. Ever since about 3.8 billion years ago, when the first cells began quivering in the primordial ooze, Evolution has produced a nonstop parade of inflatable noses, bizarre genitalia, awkward feeding habits, aggressively antisocial tendencies, and mucus. *So much* mucus.

Sure, filling the world with an enormous diversity of organisms that can live everywhere from polar ice caps to seething volcanic vents may not be the easiest job on the planet. And it's certainly tough when you have a limited gene pool to work with, when natural selection is constantly breathing down your neck to make everything more efficient and productive, and when an asteroid or enormous eruption could come along at any minute and wipe out most of the hard work you've done so far.

Still, it seems like maybe sometimes—just sometimes—a few of Evolution's innovations could have used a bit more thought. Sometimes—and I say this with all due respect, here, Evolution—you simply have to wonder: **WTF?!**

Awkward Solutions

"Hey, how come we're not more awesome?" people often ask Evolution. "Like, why don't we have wings?" Well, Evolution would like you to stop asking. You don't because you can't.

It would be nice if Evolution could do anything it wanted—renovate a mammal top-to-bottom, say, or stick propellers on a fish. But Evolution is a gradual process of change and adaptation, not some kind of wizard. It has to pick from a limited gene pool. It can enhance traits it finds in an ancestor, but it can't usually create anything new.

Imagine attempting to bake a gourmet cake when all you have in the pantry is spelt flour, powdered egg substitute, and off-brand "chocolate" drink mix. That's what it's like for Evolution, trying desperately to craft successful creatures from the assortment of hand-me-down supplies it has on hand. Need something to attract a female bird, but don't have genes for sense of humor, active listening, or good hair? All right. Inflatable balloon chest it is, then.

Every now and then a random mutation will give Evolution something different to work with, but . . . well, you know mutations. They're not always pretty.

This **pelican** looks like a urinal. Evolution, go home— you're drunk.

DALMATIAN PELICAN

Pelicans use their stretchy pouches to scoop up fish and flush them down their gullets. Forcing the fish down headfirst helps to prevent a nasty clog.

PEACOCK FLOUNDER

"So I've got this fish."

"Yeah."

"And it's got eyes on either side of its head."

"Right—like any normal, self-respecting fish."

"But I was thinking, what if it lived on the seafloor? Then it could lie flat on its side and camouflage itself in the sand."

→

"Sure, Evolution, that seems like a smart move."

"But then one of its eyes would be on the ground."

"Hmm, that's a good point. Maybe you could reshape its body so that it's horizontal, like a stingray? Then it could lie flat on its belly."

"Ugh, that seems like kind of a project. What if I just took the normal fish and had one of its eyes move to the other side of its head?"

"Well, then it might look like something Pablo Picasso dreamed up after a scuba-diving accident."

"Hey, that guy was a genius."

Flounder start their lives looking like normal fish, but as they grow, one eye sets off on an epic journey. Over several months, it inches across the fish's face to the other side of its head. As if puberty weren't bad enough already.

GIANT THREE-HORNED CHAMELEON

Sure, Evolution, being able to see in two different directions at once is kind of nice—as long as one of those directions isn't into a mirror.

"So I think I just had a breakthrough about the giraffe."

"Oh yeah, Evolution, what's that?"

"You know how everyone else in the savanna is eating the leaves that are down low?"

"Yeah, there's been a lot of competition for those."

"Well, I'm going to give the giraffe a ridiculously long neck so it can eat leaves way up high."

"That's not a bad idea. But what if it has to reach the ground?"

"Why would it have to do that?"

"I don't know, to drink water?"

"Oh. Right. Crap."

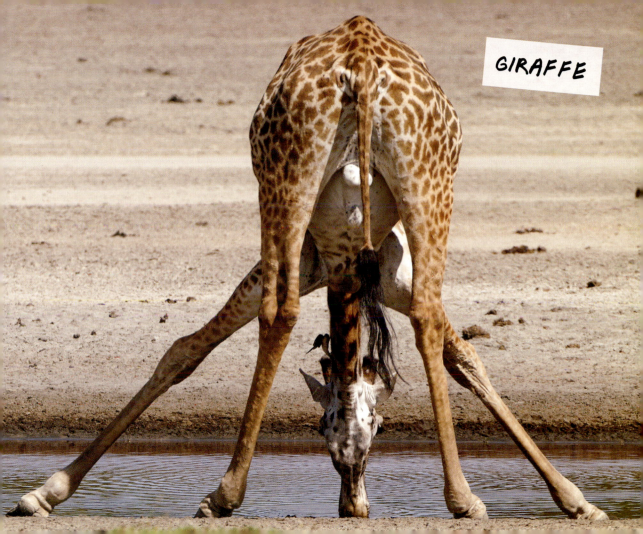

GIRAFFE

Evolution isn't sure why you're so obsessed with finding "aliens." It already made the stalk-eyed fly.

Female stalk-eyed flies prefer to mate with males with longer . . . stalks. (Why, what did you think it was going to be?)

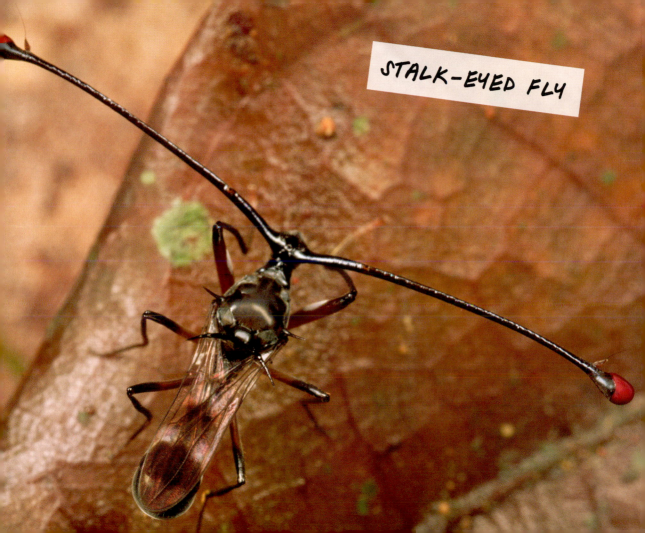

STALK-EYED FLY

MAGNIFICENT FRIGATEBIRD

hey, baby

"Hey, I need your advice for a second."

"What's up?"

"I need a way to get a female frigatebird's attention."

"Have you tried talking to her?"

"Come on, that never works. What about, like, a big red balloon? Do you think she'd go for that?"

"I guess that depends, Evolution—are you trying to convince her to mate or sell her a used car?"

Though they live off fish, frigatebirds can't dive. Instead, they often harass other seabirds until those birds puke up the fish they just caught. Then they dine on the stolen meal. More like magnificent assholebirds, am I right?

GALÁPAGOS MARINE IGUANA

Charles Darwin himself described Galápagos iguanas as "hideous."

Look, things happen. Mistakes are made. Animals that Evolution built for life on land get swept out to sea in storms and then wash up on volcanic islands where there's nothing around for them to eat but rocks.

What is Evolution supposed to do in that case? Just let them die? Of course not. Evolution is all about flexibility. Evolution is all about making do.

And if that means forcing a cold-blooded iguana to dive into frigid ocean water and graze on algae so full of sodium that he has to sneeze the excess saltwater out his nose, well then, so be it.

Nobody said adaptation was pretty.

"Whoa, Evolution, what is that?"

"That's a zebra. You already know about zebras."

"Yeah, but why is it making such a terrible face?"

"Oh, it's just trying to use the special sensory organ I buried in its upper palate to smell the pheromones from another zebra. Perfectly normal—most mammals do it all the time."

"The upper palate? Why would you put a smelling organ there?"

"Where else was I supposed to put it?"

"I don't know, the nose?"

"Oh. Yeah, I guess that would have worked."

After catching a whiff of a female's urine, a male zebra curls his lip into a grimace called the "flehmen response." That funnels compounds from the urine into chemical receptors above his mouth and helps him determine if she's ready to mate. Hey, buddy, you could just ask.

"Hey, Evolution, that newt looks nice."

"I know, it's pretty sweet. But the best part is the defense system I gave it."

"Oh, yeah? What's that?"

"See those orange spots along its side?"

"Uh huh."

"Well, when predators bother it, that's where it sticks its pointy ribs out through its skin to stab them."

"Wait, through its skin? The ribs actually puncture it?"

"Of course! How else are they supposed to get out there and impale anyone?"

"Oh my god."

"What? The skin heals back up. It's really not a big deal."

"Oh my god."

SHARP-RIBBED NEWT

Even though the sharp-ribbed newt swims in water brimming with bacteria, its self-inflicted wounds never seem to get infected—thanks possibly to special glands that produce antimicrobial compounds. See? Evolution thought of everything.

MARABOU STORK

You know that game where you draw the first part of something, fold the paper over, and then hand it to someone else, who has to keep drawing the next part without seeing what you did? That's basically how Evolution made the marabou stork.

Though they mostly scavenge for dead meat, five-foot-tall marabou storks also prey on live fish, reptiles, mice, and birds—including adult flamingos. Yum.

GREAT BLUE-SPOTTED MUDSKIPPER

To attract mates, mudskippers flex their bodies and fling themselves into the air. Then they thunk back onto the beach and flop around like fish out of . . . well, you know.

"Evolution, you'd better put those fish away!"

"What? Nah, they're fine."

"But they're not in the water!"

"Oh, they're not supposed to be. They're air-breathing fish."

"What? Since when are there air-breathing fish?"

"Since I decided to make some."

"Was that really a good idea?"

"I obviously thought so."

"But they're rolling around like they're dying."

"Yeah, they're supposed to do that. Keeps them nice and muddy so they don't dry out."

"You don't want them to dry out?"

"Of course not! They're fish."

"But they spend lots of time on land and breathe air."

"Yes. What exactly is so confusing about this?"

"Oh my goodness, Evolution, what's the matter with this thing's neck?"

"What? Nothing. I like long necks. They're . . . elegant."

"This isn't 'elegant,' Evolution; it's freakish."

"Come on, it worked on the giraffe . . ."

Male giraffe-necked weevils compete for mates by waggling their cranelike head-stalks at one another until one of them gives up and backs away.

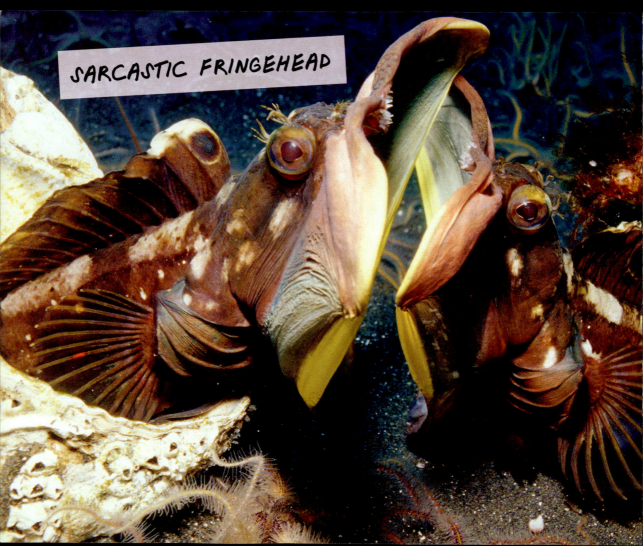

SARCASTIC FRINGEHEAD

Sometimes Evolution makes up ridiculous creatures just to watch them fight.

Immature? Possibly, but **you** *try keeping yourself amused for almost 4 billion years.*

To fight, fringeheads open their enormous jaws, spread their technicolor gill flaps, and attempt to mouth each other to death. Yeah, real scary, guys.

"Look, I made a venomous primate!"

"Oh, wow. That's a new one."

"Guess where I put the venom."

"Umm, in its mouth?"

"Nope."

"By its claws?"

"Too obvious."

"Stinging tentacles?"

"What? No."

"I don't know, Evolution, where?"

"Elbow pits."

"Excuse me?"

"They'll never see it coming."

When threatened, slow lorises—the world's only known venomous primates—lick their elbow pits to mix their saliva with oil from their pit glands and create a potent toxin. Try it next time you want to look intimidating.

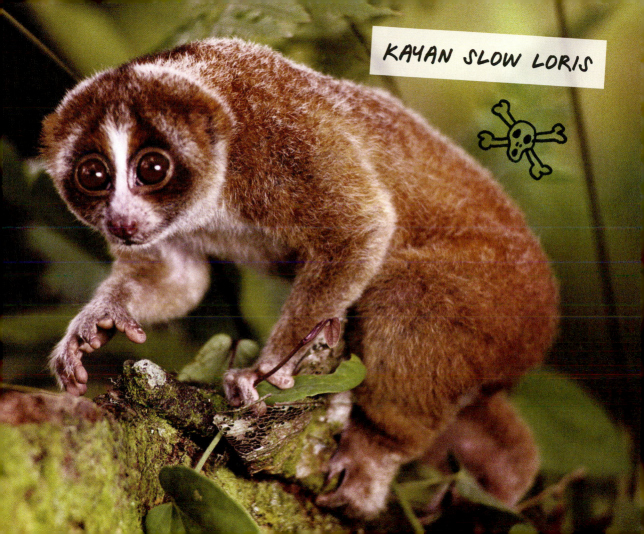

KAYAN SLOW LORIS

Plants
New Frontiers in Awkwardness

Plants are Evolution's trailblazers: They paved the way for other life to come along. First, plants helped pump loads of oxygen into the atmosphere, and then complex animals showed up to breathe it. Plants' creeping green tendrils were crawling up on land for millions of years before animals even poked their heads out of the water. They cleaned the air, fertilized the soil, and transformed the land into a place where animals could actually live. And they did it all without so much as eyeballs.

This pioneering role meant Evolution had to make plants bold. It had to make them tough. It had to make them store their own water and produce their own food and not take any crap from anybody (except the actual crap that animals poop out, which they'll gladly take and use for their own purposes). Evolution had to make plants fearless and unashamed—but in some cases, it may have gotten a little bit carried away.

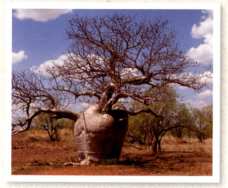

Australian Baobab
Adansonia gregorii

Tree? Giant uprooted potato? Evolution isn't certain. But the thing sure can hold water.

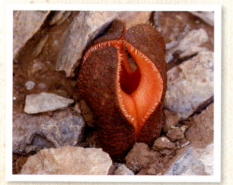

Hydnora
Hydnora africana

What do you call a parasite that sucks water and nutrients from the roots of other plants, then coughs up a flower that looks like an alien tongue? Delightful. That's what.

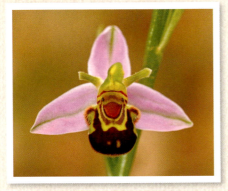

Bee orchid
Ophrys apifera

Making a flower smell like bee pheromones to trick a male bee into pollinating it? Clever. But actually dressing it up like a cartoonish lady bee? A little undignified, Evolution, don't you think?

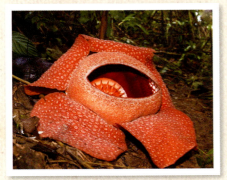

Stinking Corpse Lily
Rafflesia arnoldii

Three feet wide. Fifteen pounds. Smells like a rotting cow carcass. Gross, Evolution.

Half-Assed Attempts

Here's something you may not know about Evolution: A lot of the time, it isn't particularly trying to impress. Usually, it's just trying to make it through the eon without any enormous disasters.

Sure, sometimes Evolution really gets into it, making colorful chameleons it's awfully proud of and tropical birds with ornate feathers on their heads. But Evolution is basically just like you and me (well, besides being billions of years old and having the power to manipulate nature): Sometimes it gets lazy. Sometimes it takes all of its energy just to make a head. Sometimes a vaguely head-shaped thing will

have to do. Look, it took Evolution more than a billion years to figure out that maybe putting more than one cell together would be a good idea. You may need to lower your expectations a little.

As far as Evolution is concerned, not every organism has to be perfect—it just has to work. And as long as it works, it doesn't have to look pretty. Why waste the effort dressing up what's effectively a swimming rock when being a swimming rock suits it just fine? Evolution doesn't believe that's necessary. Evolution believes in "good enough."

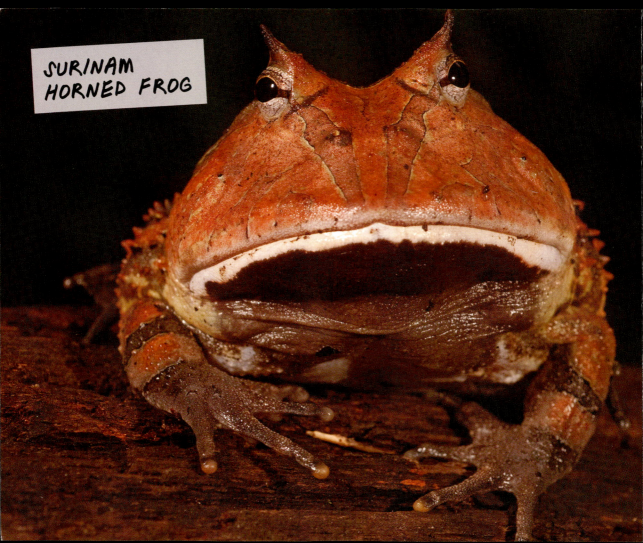

SURINAM
HORNED FROG

Evolution had not had enough coffee when it made the Surinam horned frog.

Horned frogs burrow rear-end-first under dead leaves on the forest floor, where their shape and coloring help them go undetected. Biologists call this tactic "butt-mouflage." (Okay, no they don't.)

Hey, Evolution, do you think maybe you forgot something here? Like, I don't know, the **entire back half of the fish?**

From above the water, sunfish have occasionally been mistaken for disembodied swimming dolphin heads.

OCEAN SUNFISH

ATLANTIC SAND FIDDLER

"Are you sure that you're done with this fiddler crab?"

"Yeah, why?"

"The claws are totally different sizes, Evolution."

"Come on, it's fine."

"But don't you think people will notice?"

"Don't be such a perfectionist. Let's go make some birds with funny butt feathers."

A male fiddler crab waves his one huge claw at a female down the beach, then drums it on the ground to try to coax her into his burrow. You know what they say about a guy with a big pincer. . . .

"Look, it's an eel!"

"Um, Evolution . . ."

"It lives in the rubble at the bottom of the sea."

"Yeah, okay."

"It hides in a hole with just its head sticking out, and then when a little fishy swims by, the eel snaps forward and grabs it, like THIS."

"Uh huh."

"Hey, why aren't you more excited about this?"

"Evolution, it's obviously just a sock with a guy's hand in it."

"Crap. You can tell?"

"Of course I can tell."

"Damn it. Well, just don't spoil it for the kids, okay?"

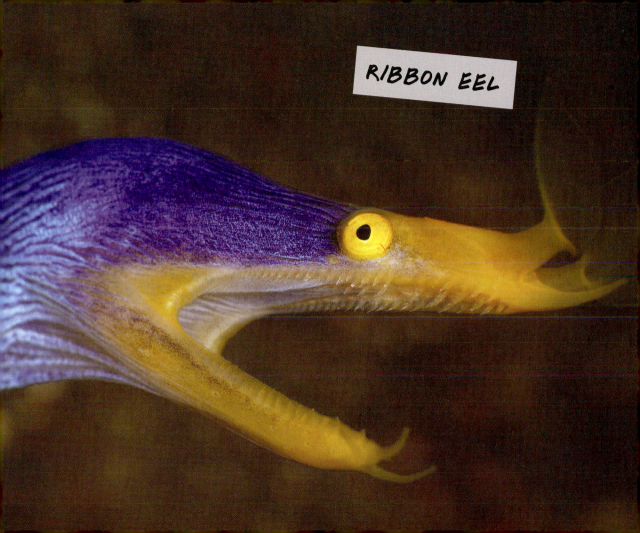

RIBBON EEL

ASIAN GIANT SOFTSHELL TURTLE

Oof

Look, Evolution, everyone has trouble staying motivated sometimes. Take a walk or have a snack when that happens. . . . Don't force yourself to make turtles when your heart obviously isn't in it.

"Hey, how's this for an octopus?"

"That's an octopus?"

"Yeah, see, it's got the eyes, the fins on top, the funnel to squirt water through, the eight arms . . ."

"Those are arms?"

"They're . . . minimalist arms."

"I don't know, Evolution. It just doesn't really look like an octopus."

"Sure it does. I think you just have to broaden your definition of 'octopus' a bit."

"Evolution, it's barely even shaped like an animal."

"Um, excuse me, who's the expert here?"

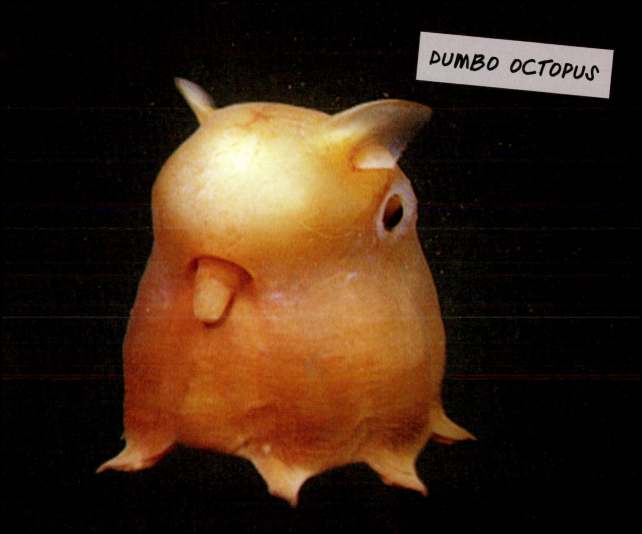

DUMBO OCTOPUS

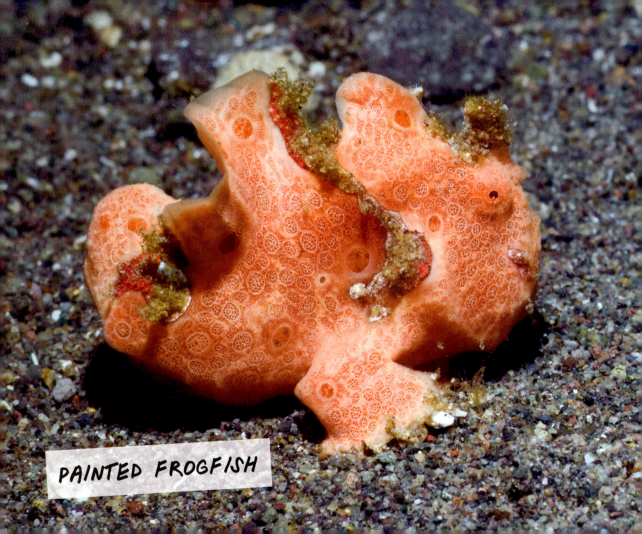

PAINTED FROGFISH

"What do you think of this frogfish?"

"Oh, gosh. That's, um . . ."

"I mean, it's still growing, so it's not quite perfect yet . . ."

"Not quite perfect? Evolution, it looks like it was drawn by a four-year-old."

"Ugh, you're right. Maybe if I drape some algae over it, no one will notice."

Adult frogfish sit in clearings and allow luscious algae to grow all around (and on) them. When another fish or invertebrate swims in to graze, the frogfish gulps them up. Yeah, who looks stupid now?

Okay, Evolution, this "secretary bird" is clearly just a person in a bird suit. At least pretend *you're trying.*

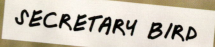

SECRETARY BIRD

The four-foot-tall secretary bird uses its deceptively spindly legs to stomp and kick its prey into submission.

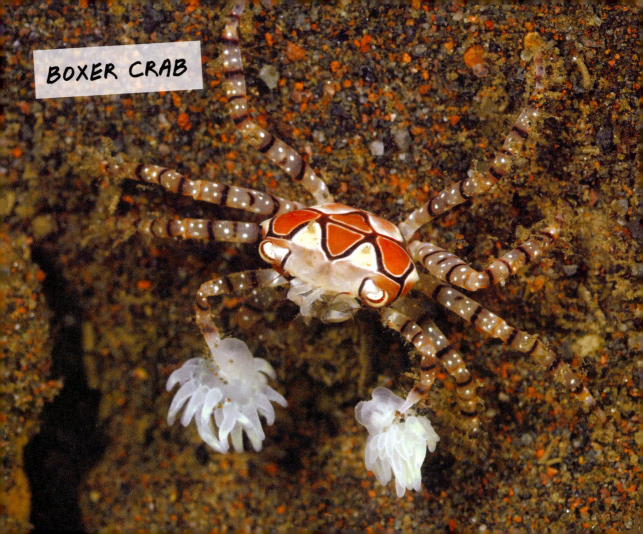

BOXER CRAB

"Look at the pretty pattern I made on this crab!"

"That's very nice, Evolution. Why are its claws so small, though?"

"What do you mean? I didn't want to block the view."

"The guy's like an inch wide; you've got to give it something to defend itself. What about a single, giant front claw like that other crab?"

"No, that would look stupid."

"Make it poisonous?"

"Ugh, toxins are hard."

"Camouflage it better?"

"Nah . . . wait! I already made sea anemones with stinging cells. What if the crab just, like, picked those up and waved them around?"

"What? How could that possibly . . . ?"

"Here, check this out."

Really, Evolution?
You've had 130 million years to work on the pignose frog, and this is the best you could do? Did you maybe boil it too long?

The pignose frog spends most of its life burrowed underground, emerging for only a few weeks every year to breed. Hey, there's someone for everyone.

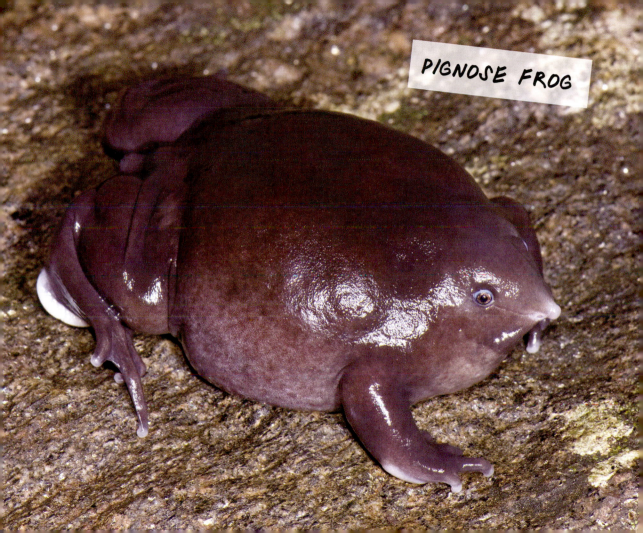

PIGNOSE FROG

IRRAWADDY DOLPHIN

These are supposed to be dolphins? Evolution, have you ever actually seen a dolphin?

Irrawaddy dolphins' flexible lips enable them to spit long streams of water from their mouths. This trick may help them herd fish into groups—or they may just think it's funny.

"Hey, Evolution, what are you working on?"

"Nothing."

"Nothing?"

"I can't anymore. I quit."

"What? You can't quit."

"Sure I can."

"But there are so many more kinds of organisms to make!"

"Nope. That's it. I'm tired. I have no more ideas."

"Not even something simple?"

"Nothing."

"Come on, Evolution, I'm sure you can come up with something."

"Fine. Here."

"What's that supposed to be?"

"I don't care. Call it a sea . . . potato."

"Yeah, you know what? Maybe you should take a break."

> The sea potato—a type of urchin—spends most of its life buried in the sand. (Wouldn't you?)

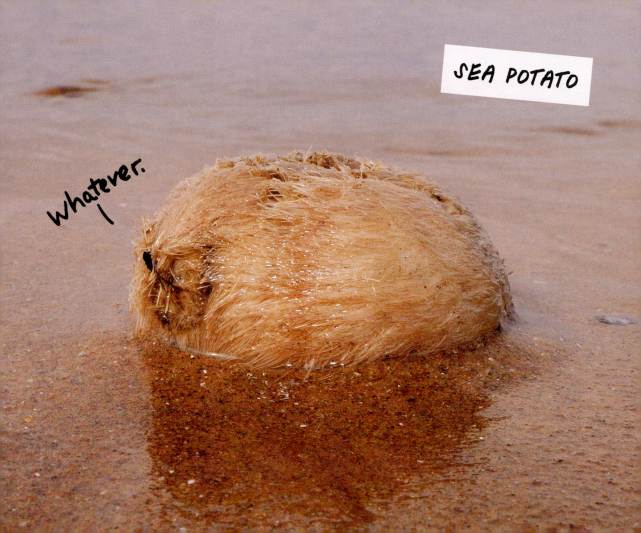

SEA POTATO

Whatever.

Evolution's Outtakes
So Half-Assed, They're All Dead Now

Evolution does its best to ensure that all the species it develops will survive and flourish. But sometimes, no matter how hard it tries, the unthinkable happens: A species goes extinct.

It's a sad but simple fact of life. Even under normal circumstances, 10 to 20 percent of species bite the dust every million years or so. Sometimes they die out because their environments change, or because faster, smarter, more-fertile types beat them out. Sometimes new diseases devastate them, volcanoes deep-fry them, or humans decide that they taste good. (R.I.P. passenger pigeons.)

And sometimes . . . look, I'm not saying Evolution was asking for it, but you have to wonder if it was ever really planning for the long term.

Who: *Josephoartigasia monesi*
What: A 2,500-pound rodent—the largest ever
When: 2 to 4 million years ago

A bison-sized guinea pig?
Sure, what could go wrong?

Who: *Platybelodon*
What: A forest-dwelling elephant relative
When: 5 to 12 million years ago

Need to scoop stuff, scrape stuff, and slice stuff?
Why not try a spork for a mouth?

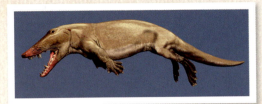

Who: *Ambulocetus natans*
What: A semi-aquatic ancestor of whales
When: 49 million years ago

Awkward on land. Awkward in the water. Just sort of awkward all around.

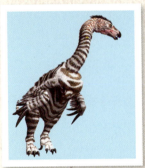

Who: *Therizinosaurus cheloniformis*
What: A large herbivorous dinosaur
When: 70 to 85 million years ago

Oh, yeah, that totally looks viable.

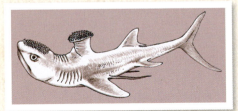

Who: *Stethacanthus*
What: An early shark
When: 350 million years ago

Who needs teeth in your mouth when you can have toothy scales on your forehead and on your weird shoe-brush-shaped dorsal fin? (You know what, don't answer that.)

Dark Times

Despite all of the cute baby mammals, funny-faced frogs, and colorful flowering plants, Evolution has its fair share of demons. Think about it: You can't witness nearly 4 billion years of volcanic eruptions, asteroid strikes, interspecies violence, destruction, and decay without turning a little twisted inside. Darkness is in the nature of the job.

Evolution loves life, sure. But it's also pretty tight with death. Evolution depends on death to clear out old, outdated organisms so that its newer innovations can take hold. Without death to do the dirty work, Evolution would be forever stuck with last millennium's model. But all that time in intimate contact with the ultimate infinite nothingness can start to seep into one's consciousness, you know?

Evolution usually tries to keep the dark thoughts to itself. It wants its life forms to be able to eat, mate, and frolic without being paralyzed by a penetrating existential dread. Sometimes it just can't help it, though, and it ends up creeping everybody out. It's a shark-eat-seal-eat-fish-eat-smaller-fish-eat-shrimp-eat-decaying-dead-shark world out there, and that means things might get a little grisly.

Dark thoughts keep Evolution awake some nights. *It tosses and turns for hours, tormented by visions of creatures too twisted for anyone else to see—creatures that it knows no decent natural force would ever even imagine. In a desperate attempt to feel normal, Evolution tries to bury these demons deep within the murky sand. Damn things keep poking their heads back out to eat, though.*

Dangly lures inside stargazers' mouths attract critters for the bottom-dwellers to snack on. They may also eat souls, although biologists have yet to confirm this.

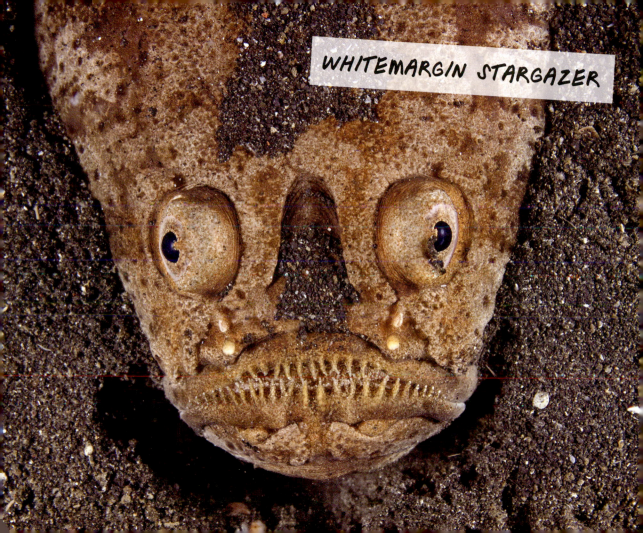

WHITEMARGIN STARGAZER

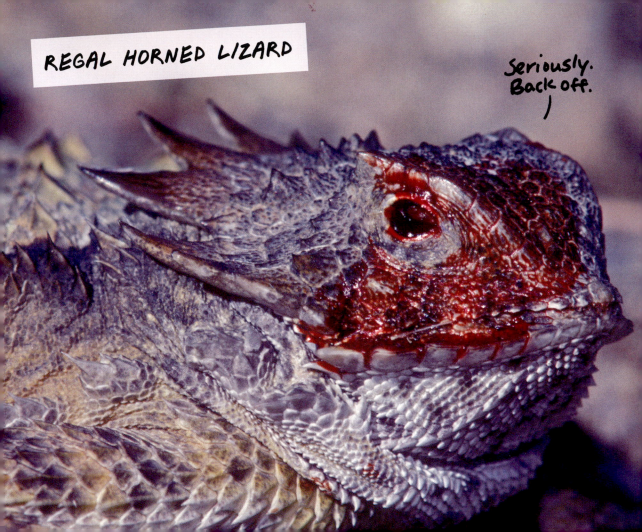

REGAL HORNED LIZARD

Seriously.
Back off.

The horned lizard fends off predatory coyotes by shooting three-foot streams of its own blood from its eye. Evolution, please seek psychiatric help.

Predators such as coyotes and foxes find the taste of the horned lizard's blood unsavory—but, as one herpetologist has helpfully noted, humans "do not taste anything strongly objectionable."

PRAYING MANTIS

A female mantis may chew off a male's head and thorax before, during, or after mating. The upside: He can finish copulating even with a severed head. The downside: Then he dies.

"I am such an idiot."

"What do you mean, Evolution?"

"I made animals that court each other and make beautiful love; I made animals that protect each other, raise their offspring together, and mate for life. Apparently, I was just being naïve, though. *Apparently,* none of those things actually matter to anyone."

"Uh-oh. Did Genetic Drift stop calling you back again?"

"Maybe, instead of cuddling after they mate, one of these praying mantises should just *eat the other one's head off* and put it out of its misery."

"Hey, you seem a little angry."

"Love is dead."

Oh no, Evolution. Whatever it was that the bald uakari did to anger you, surely it didn't deserve **this.**

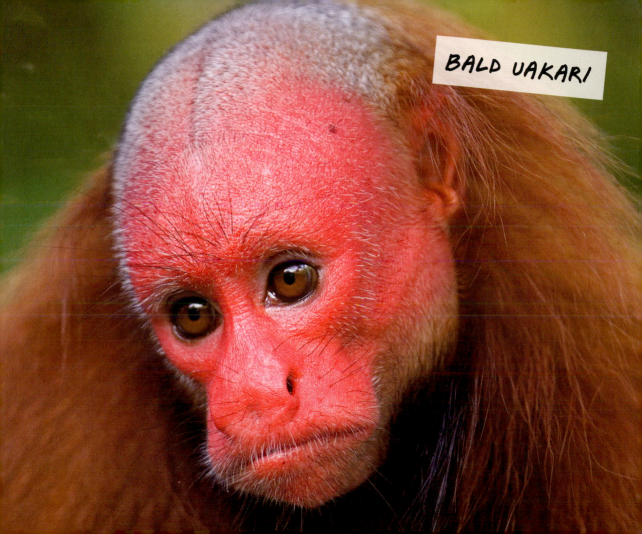

BALD UAKARI

"So you didn't like my fishes before, huh?"

"I mean, they were okay, Evolution, but . . ."

"Well, how do you like this one?"

"What is that?"

"It's a dead-eyed ghoulfish, and it's here to *haunt your dreeeeams.*"

"Oh. Cute."

"Cute? Come on, it's terrifying! Aren't you terrified?"

"Evolution. It's three inches long."

"Okay, but what if there were, like, a hundred of them? And they were all swimming around your head?"

"What are they going to do, stare me to death?"

"No, they'd . . . they'd . . . ugh, I hate you."

PACIFIC HATCHETFISH

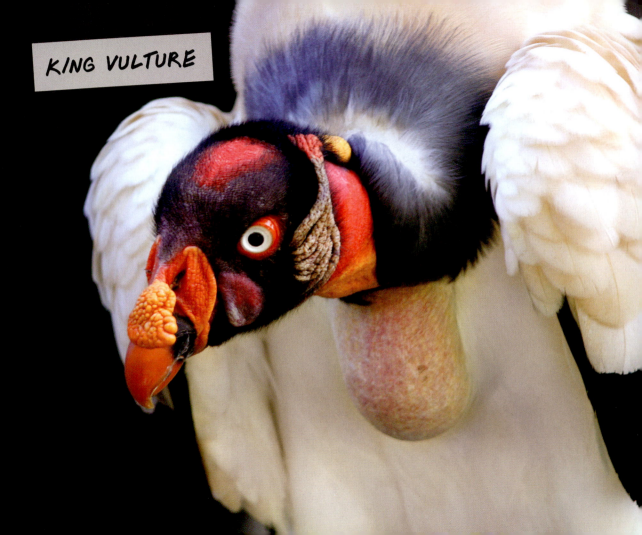

"I like what you've done with the king vulture, Evolution. It's colorful, it's modern, it's bold. . . ."

"Thanks! I'm pretty proud of it."

"One question, though."

"Yeah?"

"And pardon me if I'm being impolite here."

"No, go ahead."

"Why doesn't it have any feathers on its head?"

"Oh, that. That's just so its face doesn't get too messy when it's rooting around decaying body cavities for lunch."

"God, you're disgusting."

King vultures pick the skin and connective tissue off decomposing carcasses. That may sound foul, but as birds that keep cool by pooping on their own legs, it's not like they're easily grossed out.

VISAYAN WARTY PIG

Evolution produced the Visayan warty pig during an angsty adolescent phase. Don't ask.

The male Visayan warty pig regrows his mohawk every breeding season. It can grow almost two feet long, sometimes falling over his face and blocking his view. Get a haircut, pig.

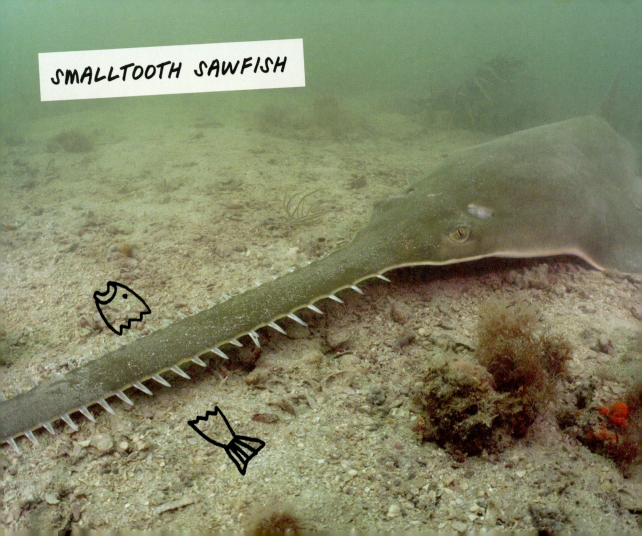

SMALLTOOTH SAWFISH

"So I've been thinking."

"Great, Evolution."

"You know how I usually put fish's teeth inside their mouths?"

"Uh . . . yeah?"

"Well, what if I made a fish with teeth on the outside? Like, all around the edges of a really long snout? Like a gigantic face-saw!"

"I'm sorry, what?"

"Think about it! It could brandish its snout to break up schools of fish. It could impale them. It could *slash a swimming fish in half!*"

"That sounds . . . unnecessary."

"No, 'awesome.' I think you mean awesome."

"Hey! Hey! I think I finally made something cute."

"Oh, yeah? Let's see."

"It's a 'shoebill.' It's big and blue and adorable. Nice, right?"

"It's . . . hmm. I don't know. I do like the blue, but something about those eyes is kind of creeping me out right now."

"What? Come on. Those are friendly eyes. It wants to be your friend."

"Okay. Okay, yeah. You're right, Evolution, I'm sorry. Should I feed it, maybe? What does it eat?"

"Baby crocodiles."

"Oh Jesus Christ."

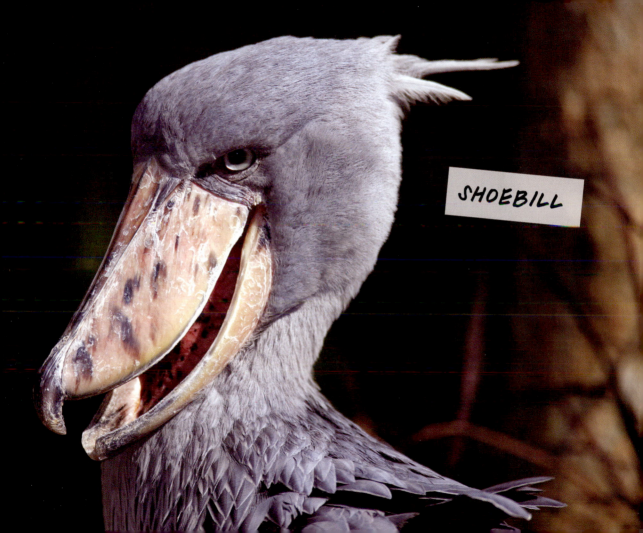

SHOEBILL

GUM LEAF SKELETONIZER CATERPILLAR

Molting is a beautiful thing. When your insides start feeling a little too big for their case, you can just crack open your exoskeleton and emerge a whole new invertebrate, freed from all the trappings of your former, smaller life.

Unless, that is, you're a gum leaf skeletonizer caterpillar. In which case, Evolution makes you stack your old heads on top of your new one and wear them all around forever like a macabre stovepipe hat. How exactly is this helping?

Evolution made the stonefish to scare small children off its underwater lawn.

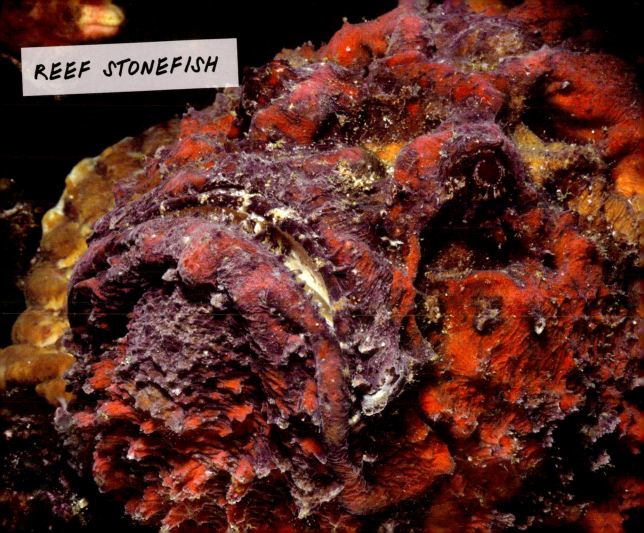

REEF STONEFISH

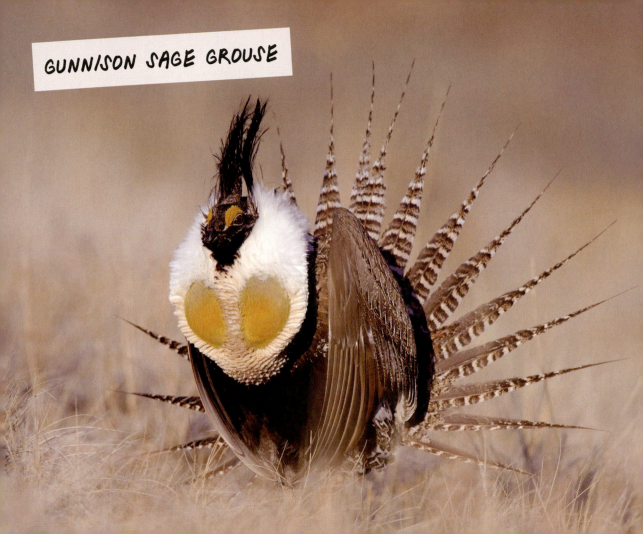

GUNNISON SAGE GROUSE

"Do you ever think that maybe there's something more out there?"

"What do you mean, Evolution?"

"I don't know, like, that there's some greater purpose for all these animals I'm making, other than just eating and pooping and having littler animals."

"I guess I hadn't really thought about it."

"I just wonder what the point is sometimes. What's stopping me from making this sage grouse look completely absurd? Why don't I just give it ear tassels and ridiculous inflatable chest balloons? Who cares? What difference does it make?"

"Aw, come on, don't talk like that."

"Why not? Seriously, I'm going to do it. See if anyone stops me. I bet you they won't."

A parasitic louse that crawls into your mouth, vampirizes your tongue, then clamps itself onto the withered tongue stub so it can ride around inside you and eat your mucus for the rest of your mutual lives? Yes. It's called symbiosis and it's beautiful.

What? Relax.

It's going to be fine. This isn't going to hurt.

You won't even miss your tongue—once the louse is latched onto the muscle, you can simply use its body as a tongue instead. These are exactly the kind of details that Evolution has worked out for you, because Evolution loves you and it wants you to be all right.

TONGUE-EATING ISOPOD

When a female isopod takes over a fish's tongue, a smaller male usually infests the gills, occasionally popping over into the mouth to mate. Apart from this indignity, the hitchhikers have little, if any, effect on the fish.

Don't mind me.

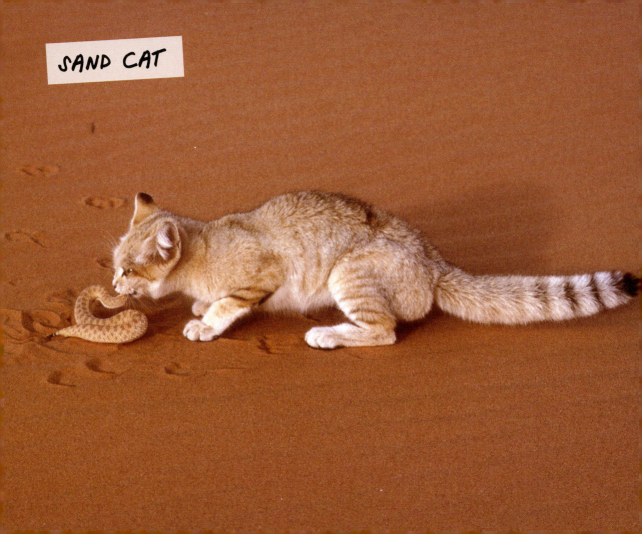

SAND CAT

"I give up. Nobody likes my stuff unless it's furry and has big eyes."

"What? Don't say that, Evolution."

"It's true! They like pandas. They like snow leopards. They like baby otters. They looove their stupid domesticated furballs. But all my intricate insects, my kick-ass sharks, my beautiful blood-shooting lizards? Oh, no, *those* are 'gross' and 'creepy.'"

"Come on, they like some nonfurry things. They like . . . dolphins."

"So? Still mammals. And I even made those guys total jerks!"

"I'm not sure what to tell you, Evolution. Maybe you should have made people invertebrates if you wanted them to relate better to centipedes and stuff."

Large, wide-set ears help the desert-dwelling sand cat detect prey moving among the dunes or scurrying underground. (They also make sand kittens freakishly adorable.)

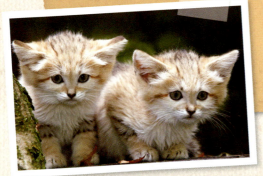

"You know what? **Fine.** I'm going to give them the cutest, furriest, biggest-eyed, and babiest-faced mammal on the planet, and then I'm going to make it chomp venomous desert vipers to death. **How about that?"**

"Yeah, they're still going to think it's cute."

"Seriously? Ugh, morons."

Dispatch from a Disaster
The Permian Extinction

To: Biodiversity
From: Evolution

February 12th, 251 million years ago

My Dearest Love,

It is with a heavy heart that I write to you today. Something terrible has happened. I don't know what, exactly—it could be that a meteorite struck earth, or maybe there was a massive volcanic eruption that darkened the skies, acidified the oceans, and filled the atmosphere with poisonous gas. It's hard to tell.

 All I know is that I woke up and everything was dead. The trilobites? Dead. My pretty horn- and honeycomb-shaped corals? Dead. Those pareiasaurs I worked so hard on—the great lumbering turtlelike things with

the armored jowls of which you were so fond? Dead, dead. I managed to salvage a few starfish and sea urchins, thank goodness, but all of the rest of them are gone.

I just don't understand it. I thought everything was going so well. They say that more than 90 percent of the species I'd made were snuffed out—just wiped off the face of the planet forever. What was once a rich abundance of plant and animal life forms is now just . . . clams, mostly. Bloody clams.

It's cold here now, strangely empty, and silent but for the occasional pop of methane escaping from a decaying animal carcass. I feel a wrenching in my stomach and a creeping desolation in my heart.

I only hope that I can recover from this horror and get back to making organisms again. Maybe this time I can make them better, stronger, and more resistant to catastrophic change. Maybe this time I can make them last.

I don't know, maybe I'll make some forty-foot-long carnivorous reptiles. Surely nothing could kill off those.

Forever yours,
E

Dirty Jokes

From an evolutionary standpoint, reproducing is the single most important thing you can do in your time on this planet. In fact, it's the only thing that really matters *at all*. In light of that, Evolution has taken pains to ensure that reproduction is always as pleasant, simple, and undisturbing a process as possible.

Ha! Just kidding, of course. It's usually totally horrifying.

Evolution has come up with millions of different ways to mate, and most of them are exceedingly strange. And hey, I'm not judging—whatever floats an organism's boat, you know?—but it just seems like some creatures *may* have preferred, say, asexual budding like a coral to the bizarre sexual rituals that Evolution puts them through.

Even when Evolution isn't working on the reproductive system, it often seems like it has sex on the brain. And although that's nothing to be ashamed of—everyone thinks about it, Evolution, you've made good and sure of that—the results can sometimes get a little bit obscene. Think you've got a dirty mind? Hardly. No matter how crude you may think you are, Evolution has you beat.

PROBOSCIS MONKEY

Stop it, Evolution, you're embarrassing yourself. You can't just take somebody's genitalia and stick them on a monkey's face.

The male proboscis monkey's nose usually dangles in front of his mouth, but it inflates and points forward when the animal gets angry or excited. It's an odd look, but an improvement over infancy: When they're born, the monkeys' faces are completely blue.

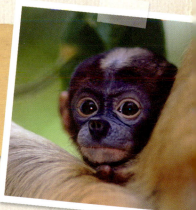

It's just a fact of life that courting males have to woo females with the sexual display characteristics they **have**, not the sexual display characteristics they might **want**. But come on, Evolution, inflatable horns and a flappy turquoise bib? At least give a guy **something** to work with.

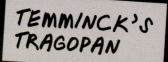

TEMMINCK'S TRAGOPAN

After calling to a female, the male tragopan conceals himself while he erects his horns and unfurls his chin-flap. He bobs his head and makes a series of loud clicks before finally revealing himself to her. Hey, at least he's got the element of surprise.

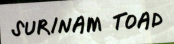
SURINAM TOAD

"Hey, I just realized."

"Yeah, Evolution?"

"A lot of the animals I've made so far have to fertilize their eggs and leave them outside somewhere, where all sorts of bad things can happen to them."

"Mm hmm."

"What if a female could keep the fertilized eggs inside her body to protect them while they grow?"

"That seems like a promising line of thinking."

"Maybe I'll make this frog's back all squishy and embed her eggs in there. Then the developed babies can crawl out through holes in her skin."

"Yeah, I don't think you've quite perfected this idea yet."

"Ooh, look, you can see them wiggling around in there!"

"So, I was thinking."

"Great, Evolution."

"Nobody really *needs* eyeballs and limbs and all that, right? When you get down to it, all you really *need* to be alive is an opening for stuff to go in and an opening for stuff to come out."

"Well, yeah, I guess so."

"I might try making things that way for a few million years—sea cucumbers and the like."

"Okay, but it's not just going to be, like, a tube with a mouth and a butthole, is it? That sounds a little crass."

"What? Of course not. It's also going to have tentacles for feeding and a bunch of sticky white filaments that it can forcefully expel out of its butt when it gets mad."

"Oh god."

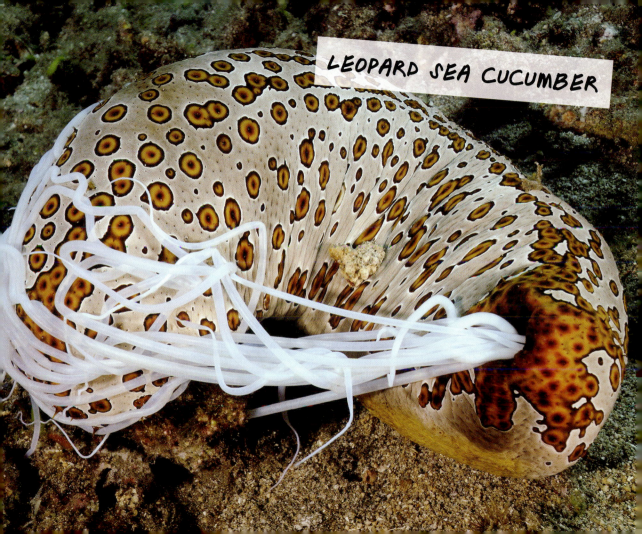

LEOPARD SEA CUCUMBER

*Okay, Evolution, did the Indian balloon frog lose a bet or something? Because making it look like a **tiny pair of testicles** just seems cruel.*

INDIAN BALLOON FROG

LEOPARD SLUG

Slugs have both male and female sex organs, so any two individuals can mate—a handy feature when you move so slowly that it may take days to find another slug.

"Wow, Evolution, what are those slugs doing?"

"They're mating by moonlight! Isn't it beautiful?"

"It does look rather elegant. How does it work?"

"Well, first they spend an hour slowly circling each other on a branch to get in the mood. Then they embrace, wrap their bodies tightly around each other, let go of the branch together, and hang midair from a rope of mucus while they tenderly make love."

"Wow, that's . . . that's actually pretty romantic, Evolution. I didn't know you had it in you. And what's that pretty flower-shaped thing that they're making at the bottom there? Some kind of delicate egg sac?"

"What? Oh, no, those are their enormous intertwined penises."

"Oh god, what?"

"Yeah, they're about as long as their bodies. Good night!"

"Oh my god, Evolution, that looks like a—"

"A snake, I know! But it's not actually a snake, it's a caecilian."

"No, I mean it looks like a—"

"Yes, it's a common mistake. Caecilians look like snakes or worms, but they're actually more closely related to frogs and salamanders. I can be tricky like that!"

"Fine, Evolution, but what I'm saying is that it looks exactly like a giant, purple—"

"Amphibian. It's an amphibian."

"You know what, never mind. Go for it, it looks great."

EISELT'S CAECILIAN

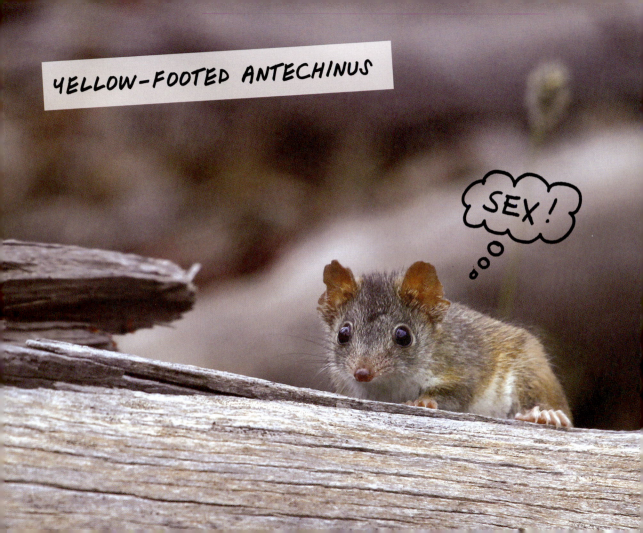

"Oh, what a cute little mouse!"

"It's not a mouse! It's a marsupial called an antechinus."**

"Sorry, Evolution, my mistake. Still cute, though."

"Isn't he? And he's excited, because he's almost eleven months old, and that means he finally gets to start mating."

"Aw, how sweet."

"He's going to run around getting it on with as many females as he can for the next two or three weeks."

"That's . . . nice."

"And he'll have sex with each of them for **up to 14 hours at a stretch.**"

"That's . . . um . . ."

"And he'll get **so exhausted** from all the frantic mating that his fur will start falling off, and **he'll contract gangrene.**"

"What? Jesus. Does he get to take a break, at least?"

"Nah, not really. He basically keeps doing it until he gets so sick and stressed out that he dies. 'Suicidal reproduction,' I'm calling it."

"Are you serious? He's going to mate himself to death?"

"Yeah, but he doesn't know it yet. Happy coming-of-age, little guy!"

"You're sick, you know that?"

PIGBUTT WORM

Look, Evolution **knows** *how to make worms. It makes worms all the time. It was making worms for hundreds of millions of years before you were even born. Evolution has made worms that break down soil so plants can grow. It's made worms that thrive in the scalding water around deep-ocean volcanic vents. It's made worms that prey on live fish and worms that pull nutrition from the bones of decaying whales. It's made a lot of damn good worms, all right?* **So just because one little worm came out looking like a tiny floating disembodied butt with genitalia, that doesn't mean you have to get all giggly about it.**

VERVET MONKEY

` what ?

"I'm worried this vervet monkey's testicles aren't noticeable enough."

"Are you serious? They're testicles, Evolution. They're obscenely noticeable."

"I don't know . . . let me just try one more thing."

The colorful scrotum of the male vervet monkey signals his social status to the rest of his clan. When a male is stressed out or attacked, his family jewels fade to a paler hue. It's okay, monkey—it happens to everyone sometimes.

"Oh man. I just had **the best** idea."

"What now?"

"You know how female kangaroos are never having enough babies?"

"They're not?"

"Well, what if I just gave them more vaginas?"

"Excuse me?"

"Yeah! Like, I don't know, three of them? That way they could get impregnated up one, pop a baby out another, and have an extra for a rainy day."

"Evolution, that's pretty messed up."

"This is going to be **so awesome.**"

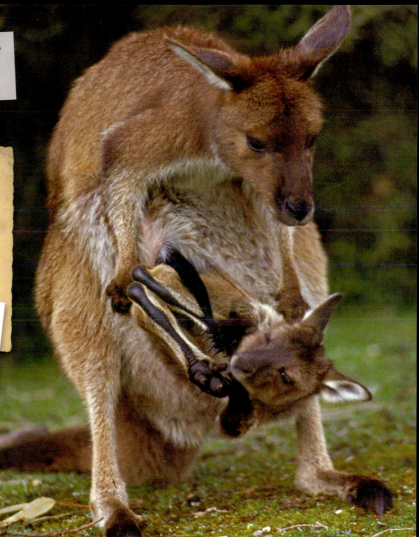

WESTERN GRAY
KANGAROO

Male kangaroos often fight for the chance to father babies—battles which, although vicious, appear more than a little absurd.

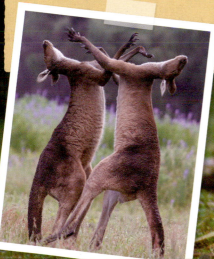

PACIFIC GEODUCK

The geoduck clam has a hinged shell for protection, a muscular foot to help it dig into the sand, and a long, meaty siphon that can extend more than three feet to suck nutritious phytoplankton from the seawater above.

Evolution is very proud of this one, and there is nothing funny about it.

Geoducks (pronounced "gooey-ducks") can live for more than 150 years. And they're fertile for at least a hundred of them, *ladies.*

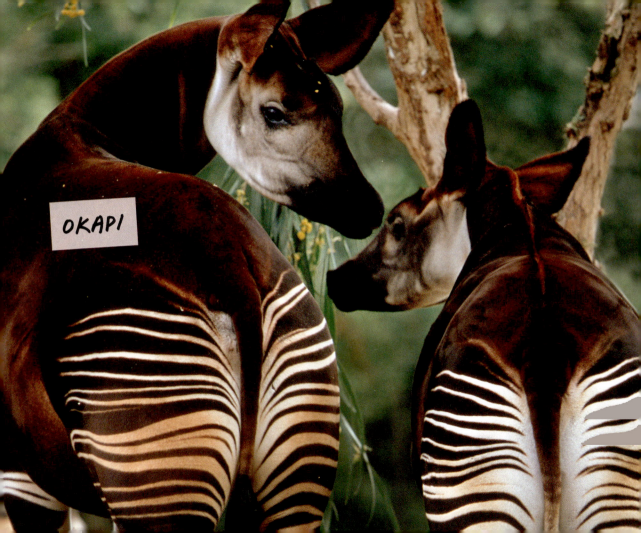

OKAPI

"Do these stripes make the okapi's butt look big?"

"Hmm. I'm not sure 'big' is the word for it."

"They're for camouflage."

"I see. Very subtle. Don't you want to camouflage the rest of their bodies, though?"

"Nah. Just the butts should be good."

Okapis' rear-end patterns may also help calves recognize their mothers from behind.

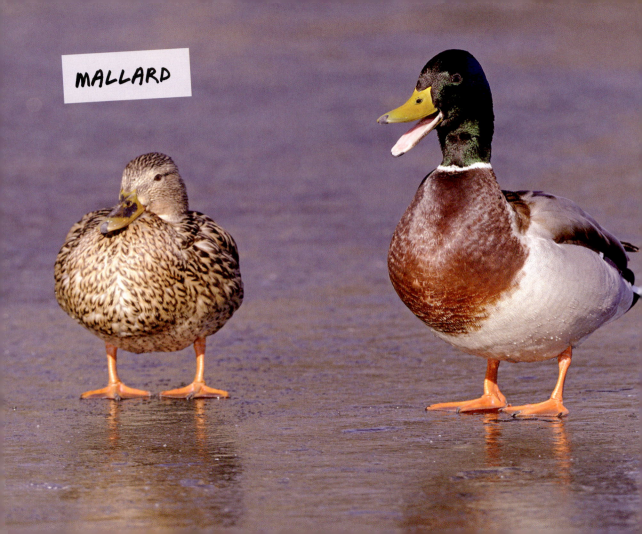

MALLARD

"Look, I made some ducks."

"Wow, Evolution, those are actually really pretty. Well done!"

"I thought so! Know what my favorite part is?"

"Is it the male's green head? That's really nice."

"Nope."

"The funny 'quack' noise?"

"Nah."

"What, then?"

"I gave the male a long, spine-covered, corkscrew-shaped penis that literally explodes into the female when they mate."

"Ew, what?! Evolution, that's horrifying."

"Oh, come on, it's fine. The female has a spiral vagina with trick passageways that keep him from getting too far in, so it all works out really nicely."

"What the hell is wrong with you?"

"Hey, Evolution, what's that? Tube with mouth and butthole again?"

"No, this is *way* fancier."

"How so?"

"Well, it has a cartilage skeleton, for one."

"Oh, that's cool."

"And four hearts to pump its blood around."

"Neat."

"And it can tie itself in a knot."

"Impressive!"

"And it exudes unholy amounts of slime."

"That's . . . hmm, okay."

"And it has a long and slender body so it can tunnel into other fishes' mouths and buttholes and eat their viscera from the inside once they're dead. Or sometimes while they're still alive!"

"Jesus. Can we go back to sea cucumbers? I never realized how much I liked sea cucumbers."

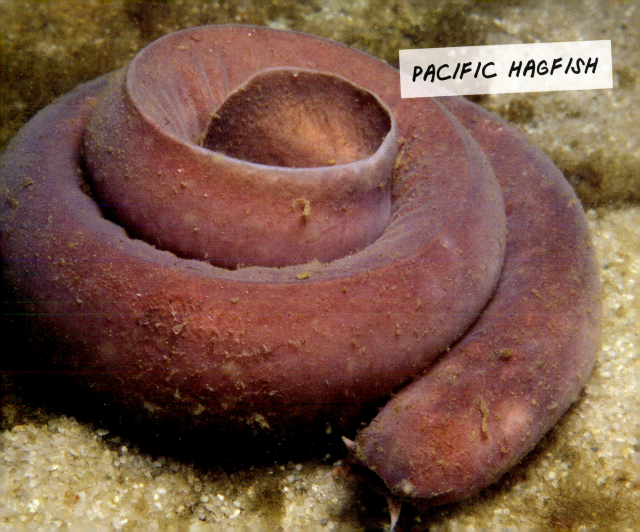

PACIFIC HAGFISH

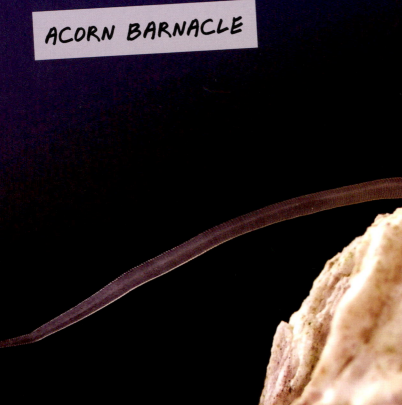

ACORN BARNACLE

"I've done it! My masterpiece."

"Evolution, that's a rock."

"You take that back. It's so much more than a rock— it's a *barnacle.*"

"A barnacle? What does it do?"

"Well, it sticks itself to stuff *really well.* It can stick to a rock; it can stick to a wooden piling; it can stick to the back of a crab—it doesn't care. It just sticks to whatever."

"Huh. And then it just . . . sits there?"

"Of course not! It builds a shell around itself, so that no one can mess with it, and then it uses a big feathery arm to brush food into its mouth when the tide comes in. It's the best." →

"Interesting. So do they just spawn into the water like other stationary animals?"

"Nope! They're way cooler than that. They get to have sex."

"What? Come on, how on earth can they have sex? They can't even move."

"Easy. I gave them the longest penises in the animal kingdom."

"Excuse me?"

"Yep. Up to eight times their own body length."

"Oh god, THAT'S what that is?"

"Now are you impressed?"

Birds-of-Paradise
Evolution Gets Some Tail

If there's one thing Evolution cares about, it's making sure you can attract a mate. It may have gone a *little* overboard, though, when it came to the birds-of-paradise. This group of birds in New Guinea and Australia has evolved various intricate and flashy feathers for the sole purpose of attracting female birds. They show off their goods in elaborate displays where they bob their heads, flap their wings, and waggle their butts like they're on the competitive merengue circuit. Amazingly, this works.

Evolution had to make some trade-offs for these decorations, of course. The long, dangly head wires of the King of Saxony bird-of-paradise are cumbersome to carry. The ribbon-tailed astrapia's three-foot-long tail feathers can get tangled in branches while the bird is foraging, making it hard to fly off quickly if he needs. But hey, who cares about flying and other basic bird functions when all the ladies want to hump you, right?

Family Tree of Sexiness

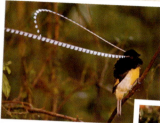

KING OF SAXONY
BIRD-OF-PARADISE
Pteridophora alberti

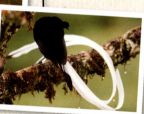

RIBBON-TAILED
ASTRAPIA
Astrapia mayeri

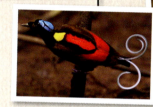

WILSON'S BIRD-OF-PARADISE
Diphyllodes respublica

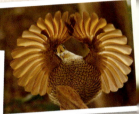

PARADISE RIFLEBIR
Ptiloris paradiseus

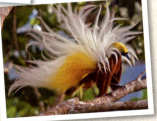

LESSER BIRD-OF-PARADISE
Paradisaea minor

Questionable Design

Evolution likes to consider itself an artist. Like an eccentric modern painter, though, its motives are occasionally somewhat obscure. And sometimes its artistic visions don't pan out exactly how it planned.

Part of the problem is the medium: It's not always so easy to express yourself through genes. They can be tricky and unpredictable, and one little change in the blueprint may have many unintended effects. Sometimes Evolution wants to draw out one particular trait, for example, but some other, stranger one sits right next to it in the genome and so has to come along for the ride.

Of course, from Evolution's perspective, there are rewards for being weird. The more distinct an organism is from everything else around it, the less it will have to compete. Live somewhere no one else does? Eat something no one else likes? Move in a way that your predators can't? Good. Maybe you won't go extinct just yet. (Hang in there, bud.)

So okay, Evolution, get creative. Do your thing. But look, an art class every now and then may not be the worst idea.

"Hey! Check out this perfectly normal bird."

"Wow, Evolution, it's . . ."

"It's a pretty good size for a bird, right?"

"Yeah, the size looks fine."

"And it lives in the trees, like a bird should."

"That does seem appropriate."

"And it has a good birdlike beak and perfectly reasonable bird colors and sufficiently functional bird wings. I really don't see what you could complain about with this one."

"Yeah, Evolution, it's just that . . ."

"What? What could *possibly* be wrong with this bird?"

"I'm sorry, but what the hell is that thing on its head?"

"Oh, that? I don't know. I just liked it."

HORNED GUAN

BABIRUSA

Why so gloomy, babirusa? Is it because Evolution gave you some weird extra tusks that are ugly, useless, too brittle to fight with, and may eventually grow so long that they curve around and fatally puncture your skull? **Could that be it?**

A babirusa's tusks start out growing inside its mouth, then pierce through the skin of its face and just keep going. Talk about a nightmare of orthodontia.

Evolution briefly flirted with a career in hairdressing before realizing that it wasn't really its thing.

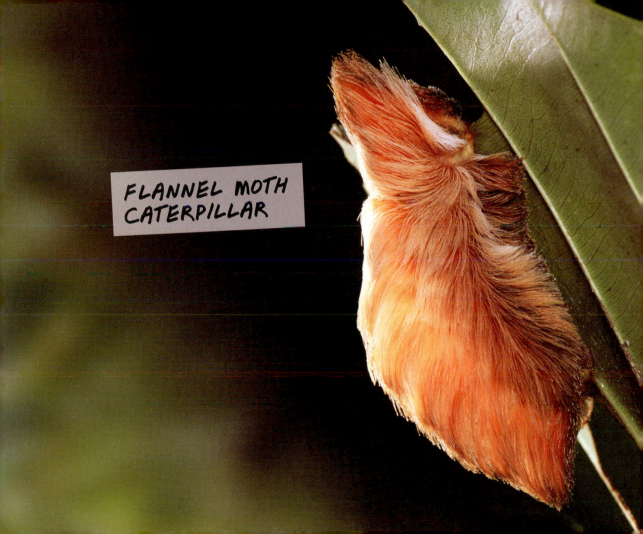

FLANNEL MOTH
CATERPILLAR

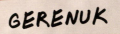

GERENUK

— Empire
State
Building
(for scale)

Look, Evolution, I don't want to tell you how to do your job or anything, but the proportions on this gerenuk just seem a little . . . off. Are you sure you didn't mess up a unit conversion somewhere?

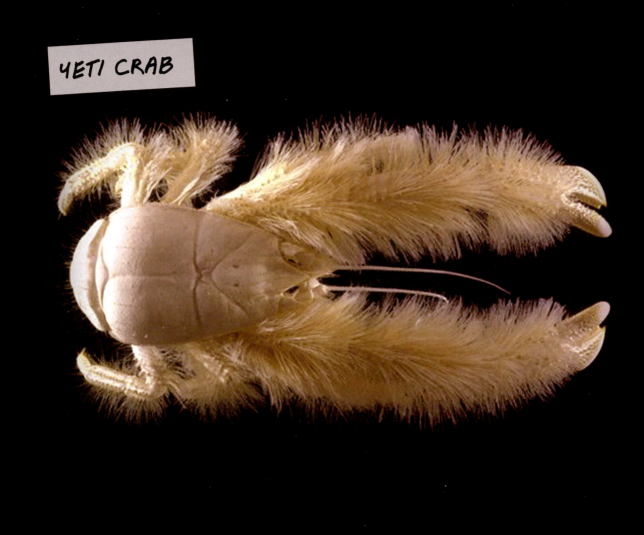

YETI CRAB

"Oh god. I don't know what to do."

"What's the matter, Evolution?"

"Apparently I need to adapt this crab so it can survive next to a hydrothermal vent. A hydrothermal vent!"

"Oh, wow, yeah. That's a tough one."

"I mean, there's barely any food down there. Those vents spew 700-degree water. They're basically fountains of death. How on earth am I supposed to make a crab that lives there?"

"Yeah, that seems like it could get a little hairy."

"Ooooh. Now there's an idea."

"Wait, what? No, that wasn't what I . . ."

"Thanks!"

"Whoo boy."

The yeti crab's hair hosts millions of sulfur-loving bacteria, which feed on the chemicals seeping from the vents the crab calls home. When the crab needs a snack, it simply scrapes some of its bacterial crop into its mouth. Doesn't get more locally sourced than that.

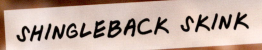

SHINGLEBACK SKINK

Look, Evolution, *we've been over this.* If a cold-blooded lizard gets too hot, you need to make it go sit in the shade for a while. You can't just feed it popsicles all day.

Slow-moving shinglebacks waggle their blue tongues when they feel threatened. Perhaps not the most frightening of displays, but hey—that's what they've got.

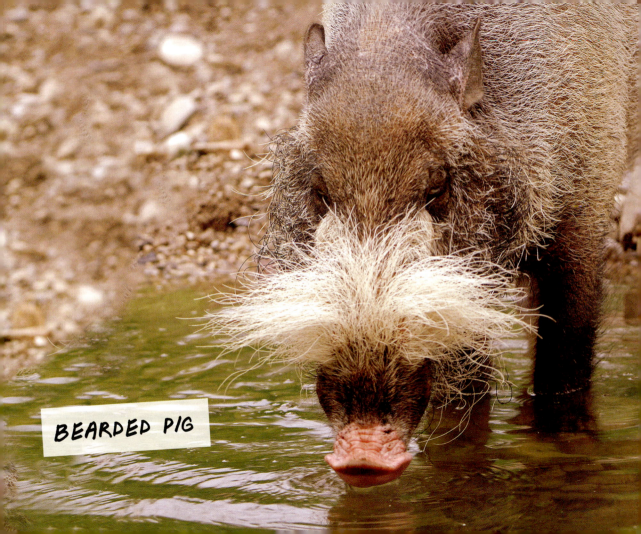

BEARDED PIG

Hey, Evolution, *I know that beards are in and all, but I think you may have put this pig's on backward. Or upside down. Or inside out?* **Possibly all three.**

Bearded pigs use their scruff to dig around for roots, fungus, and bugs to eat. They also snarf down plants, small birds, and the occasional orangutan carcass. (It's a pain getting the ape gristle out of your beard, though.)

"Look, I decorated this moth."

"Wow, Evolution, that's . . . lovely."

"Festive, don't you think?"

"Yeah, I guess so. . . . What did you use?"

"**Fungus!** It's super easy: You just have to get the spores onto the moth, and then they grow inside its body and sprout out into those pretty branches all by themselves."

"And the moth is cool with that?"

"What? Oh, I don't know, the fungus kind of exploded its brain. **But doesn't it look neat?**"

CORDYCEPS FUNGUS

Some species of *Cordyceps* can control their hosts' behavior, compelling them to climb onto a high leaf before they die so that the fungus can disperse its sinister spores far and wide.

ATLANTIC WOLFFISH

The wolffish is actually modeled after Evolution's cousin Frank. Evolution has always secretly hated its cousin Frank.

EMEI MUSTACHE TOAD

"Hey, what do you think of this look?"

"I don't know, Evolution, it's a little . . ."

"A little too trendy? A little too cool? A little too likely to make all the other toads feel inadequate because they don't have super stylish mustaches?"

"Sure, yeah, something like that."

Every breeding season, the male mustache toad grows a new set of upper lip spines, which he uses to battle rival mates. During these fights, he tries to wrestle his opponents off the ground and impale them with his own spike-studded face. Well, that's one way to win a lady.

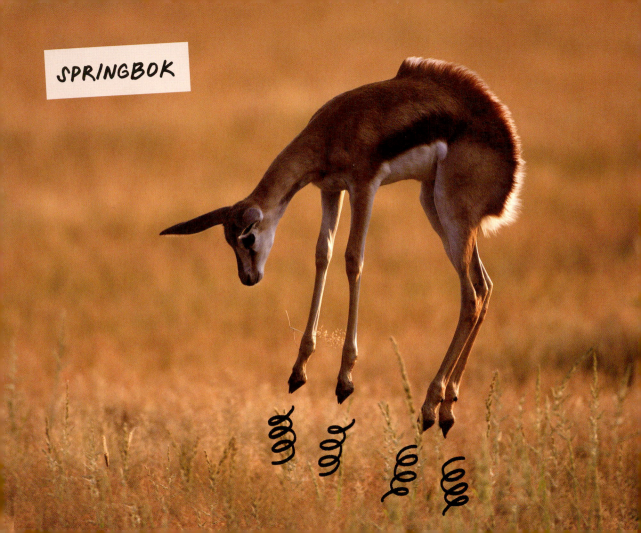

SPRINGBOK

"Check out this awesome dance move I invented."

"Do I have to?"

"Look, you bounce into the air, you point your head down, and you fan your butt hair out, like this."

"Oh my god, Evolution, please stop doing that."

"What? It's called 'pronking.' All the springbok are into it."

"I can't take you anywhere."

"*Pretty horns on that planthopper, Evolution.*"

"**Those aren't horns. They're waxy filaments.**"

"*Oh, well, whatever. Pretty head filaments. Very dapper.*"

"**What? No, no, no, that's not its head. That's the butt.**"

"*It's . . . oh god, it is. Why on earth would you put those there?*"

"**They're for defense.**"

"*I'm sorry—how do party streamers coming out of its butt constitute defense?*"

"**Well, do you want to eat it?**"

"*I mean . . . no, but . . .*"

"**Mission accomplished, then.**"

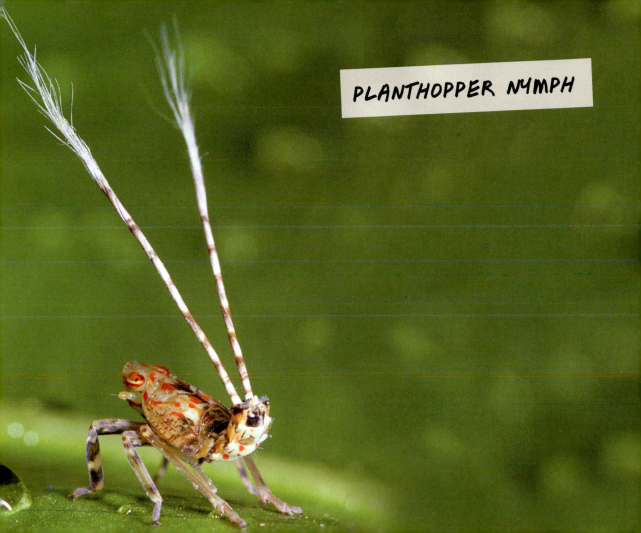

PLANTHOPPER NYMPH

TASSELLED WOBBEGONG

"Hey, how should I disguise this wobbegong so that nobody knows it's a shark?"

"I don't know, Evolution—mottled colors, bumpy skin, the usual camouflage stuff?"

"Ooh, how about a fake beard?"

"What? Come on, that never works."

The wobbegong's fringy beard breaks up the outline of its head, making the shark harder to spot against a background of reef plants or rocks. Its wife totally hates it, though.

Evolution brought this sea sponge back from the future. And the future is . . . **still pretty weird.**

PING-PONG
TREE SPONGE

"Hey, check out this badass spider I made."

"Whoa, Evolution, that's . . ."

"I was giving it some normal-size horns, and then I thought, *Hey, why not make them a little bigger?* And that looked pretty cool."

"Uh huh."

"And then I thought, *Why not make them even bigger than that?* And that looked even cooler."

"I see."

"And then I thought, *Why not make them so ridiculously big that it seems like the spider might actually topple over at any moment because the horns are so much longer and taller than its body?* And that looked *totally awesome.*"

"Yeah, it's . . . impressive. Is the spider going to topple over, though?"

"I don't know. Let's find out!"

LONG-HORNED
ORB WEAVER

Scientists don't
know much about
these rare Asian
spiders, but their
massive spines may
deter predators by
making the spiders
too awkward to
swallow.

DUCK-BILLED PLATYPUS

The first zoologist to examine a taxidermied platypus checked to make sure it wasn't a stitched-together fake.

"Hey, Evolution, can I get rid of some of this stuff?"

"What stuff?"

"Whatever's in this back cabinet here. Looks like some extra duck bills, beaver tails, a jar of, umm . . . venom? I think that's venom."

"Leave that alone."

"What does the label on this one even say? 'Electrically sensitive mucous glands'? Well, that doesn't make any sense. Yeah, I'm tossing all of this."

"No! I'm saving that stuff. I need it."

"For what?"

"For . . . a project."

"Come on, be realistic. You haven't touched any of this in millions of years. And we need to make some room before you get started on all the big mammals."

"No! I'm definitely going to use it. I actually— I actually need it right now. All of it."

"Seriously? For what?"

"For this, uh . . . this animal with a duck bill and a beaver tail and venomous spurs on its ankles and electrically sensitive mucous glands in its face."

"You're making that up."

"No, I'm not. It's called, uh . . . it's called . . . a platy . . . pus."

"Whatever, Evolution. Just organize these shelves for once, okay?"

Evolution's Devious Tricks
Camouflage and Mimicry

There's nothing Evolution loves more than a good prank. That's why it's spent hundreds of millions of years perfecting the mischievous art of making things look like something they aren't.

Evolution has come up with infinite variations on the old visual gag. Hiding animals in plain sight? Fun times. Disguising an edible bug as an inedible tree part? Nice. Setting out something that looks like food but will actually—surprise!—eat you? Hilarious!

Is it cruel? Maybe a little. But, oh man, did you see the look on that bird's face in the half-second before the snake (that it didn't realize was a snake) fanged it to death? *Classic.*

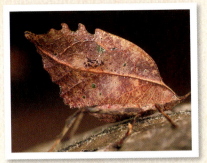

Leaf-Mimic Katydid
Typophyllum sp.

Looks like a dead, decaying leaf, right? Psych! It's totally a bug. Good one, Evolution.

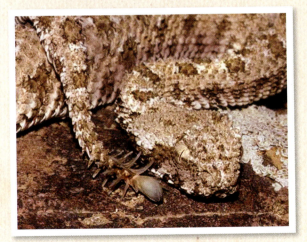

Spider-Tailed Horned Viper
Pseudocerastes urarachnoides

This snake twitches its spider-shaped tail to make it skitter around like the real thing. When a bird tries to peck at the spider, the snake suddenly kills it and eats it. Gotcha!

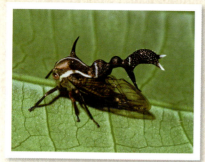

Ant-Mimic Treehopper
Heteronotus sp.

Shh! Predators will never know it's not a ferocious . . . ant.

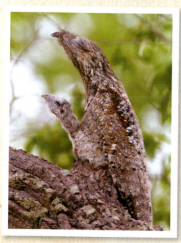

Great Potoo
Nyctibius grandis

By night, a wide-eyed predatory bird (and chick). By day—piece of a tree. So clever!

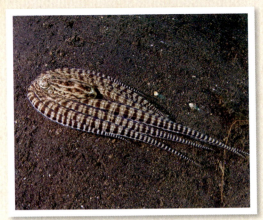

Mimic Octopus
Thaumoctopus mimicus

This octopus wards off attackers by changing its shape and color to mimic various ocean creatures, from a frilly lionfish to a long, skinny sea snake. Here it impersonates a terrifying flounder. Get it?

Bird-Dropping Crab Spider
Phrynarachne decipiens

To attract flies, this spider looks—and smells!—just like a fresh, wet pile of bird crap. Hold up, Evolution, who exactly is the joke supposed to be on here?

Dreams and Hallucinations

Sometimes Evolution has visions: glorious visions, fantastical visions, or visions born of one too many beers. Yes, when it's feverish, daydreaming, or simply *super* wasted, Evolution makes some of its most beautiful and totally bizarre creatures—and then pretends it meant to do it that way all along.

The more Evolution cuts loose, the crazier its critters get. Look, even when it's *trying* to be respectable, it winds up putting hydraulic cranes on weevils and teeth up through some poor pig's face. So you can just imagine what tends to happen when altered states of consciousness get involved. When its inhibitions are down, Evolution can go with its gut—and its gut, it turns out, likes even stranger shapes, unexpected outgrowths, and enough colors to make a rainbow cry. (Especially pink, apparently. For whatever reason, Evolution is *really* into pink. Don't judge.)

So Evolution likes to have a good time now and then, and that's cool—but maybe it should refrain from making organisms until at least the morning after. Sometimes inhibitions are there for a reason.

"I had the most beautiful vision last night."

"Oh, yeah?"

"This animal came to me, and it was just . . . it was . . ."

"It was what?"

"It was eight feet tall."

"Okay . . ."

"And it was of the purest white."

"Like a polar bear?"

"No, no. Better. It had a body like a horse, and a glorious, flowing mane—like a lion's."

"Hmm."

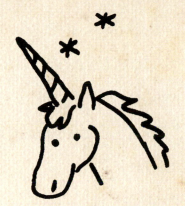

"And all the colors of the rainbow were in the mane."

"Evolution . . ."

"And on its head was a single, perfect horn."

"Evolution."

"And a brilliant light burst forth from the horn, as if by some kind of magic."

"Evolution, that's a unicorn. It isn't real."

"Do you think I can make one?"

"I doubt it. Do mammals even have any bioluminescent proteins?"

"No, but . . ."

→

"And how would you get lion hair onto an ungulate?"

"I don't know, they could hybridize . . ."

"That's not going to work and you know it."

"Okay. You're right. But maybe . . ."

"What?"

"What if . . ."

"What if what, Evolution?"

"What if I grew an enormously long tooth on a whale?"

"Interesting. And then what?"

"Then nothing. That's all I've got."

"Oh. Right. Umm, yeah, sure, that seems just as good."

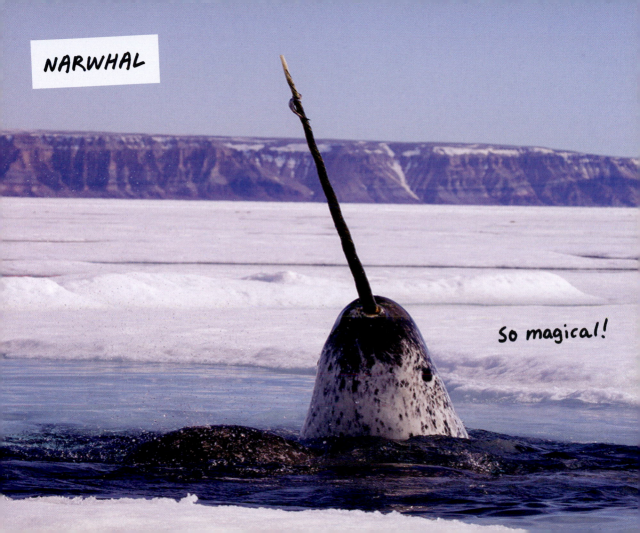

NARWHAL

So magical!

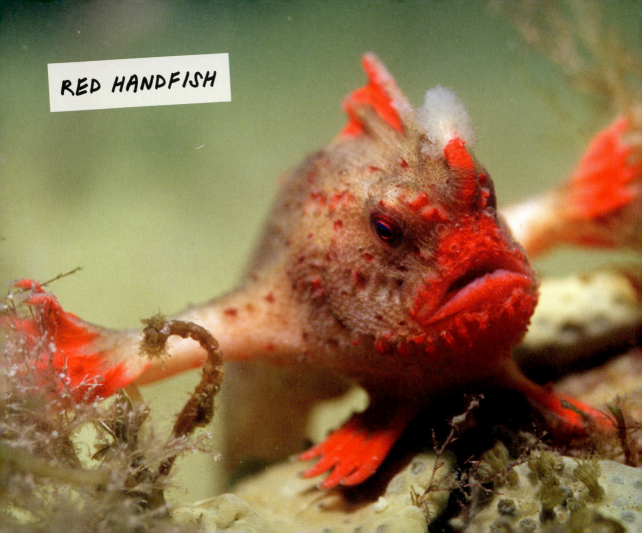

RED HANDFISH

This one time Evolution got kind of wasted at a party and was all like, "Guys. GUYS! Have you ever wondered what it would look like if fish had hands? Check this out."

Bam.

Handfish.

Baby handfish can use their fins to crawl along the seafloor as soon as they emerge from their egg cases—which is more than Evolution can say for some of us.

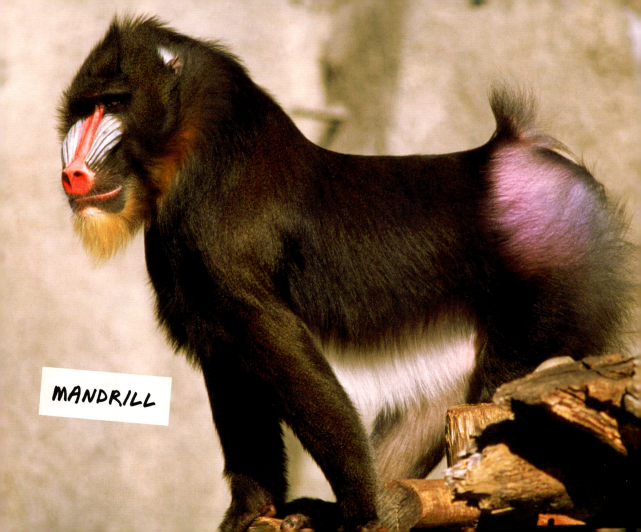

MANDRILL

"Goodness, Evolution, you look exhausted."

"I've been up all night working on the male mandrill, and I still can't get him right."

"What do you mean? He's looking pretty good to me."

"No, he needs something more. He's the largest monkey in the world, so I need to make him look strong."

"Yeah, sure."

"I need to make him look intimidating."

"Mm hmm."

"I need female mandrills to swoon and throw themselves at his feet when he walks by."

"Okay."

"I think I need to give him a rainbow butt."

"Right. Wait, what?"

"Hey! Are you ready to go to that party?"

"Do we have to, Evolution? I'm still kind of tired from the last one."

"What? Of course we have to!"

"Can't we just stay in and play Scrabble for a few thousand years?"

"Come on, all the cool natural processes are going to be there! And I made this party spider especially for tonight!"

"Party spider?"

"Yeah, we can hang it up on the ceiling like a disco ball. See? Everyone's going to love it. Now are you coming?"

"Ugh, fine. But only to keep you from getting drunk and trying to arm wrestle The Carbon Cycle again."

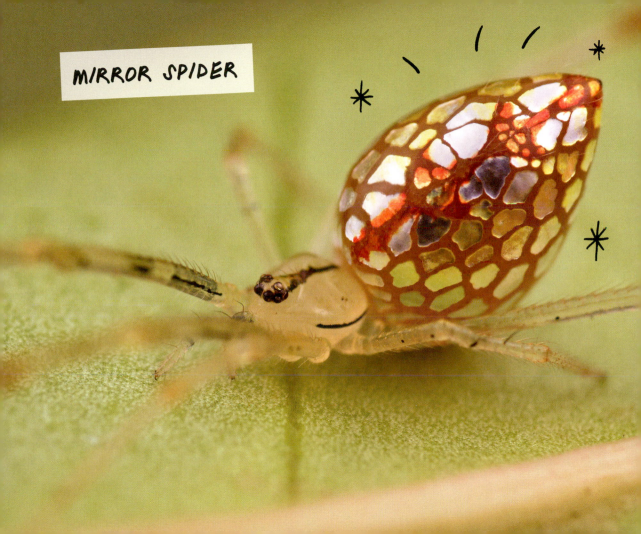

MIRROR SPIDER

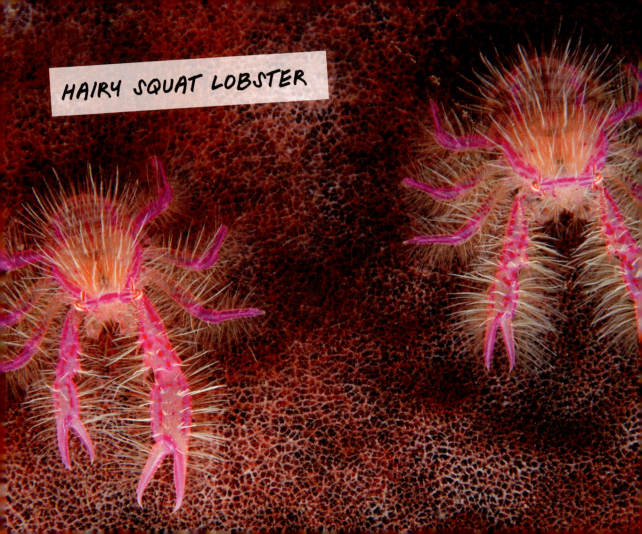

HAIRY SQUAT LOBSTER

Look, I'm not saying Evolution took anything weird at that party last night—but these are what it came up with afterward, so I don't know, you decide.

"I really don't want anyone to eat this wattle cup caterpillar."

"Sure, Evolution, that's understandable."

"I'm going to put some huge spikes on it."

"Okay."

"Now I'm going to put more spikes on the spikes."

"Okay."

"And I'll make them sting!"

"Fair."

"And I'll color the whole thing like a bad acid trip."

"That might be overkill, but all right. I guess you really like this one. I bet it'll be especially beautiful once it metamorphoses into a butterfly, huh?"

"What? Oh, no, it's a hairy brown moth."

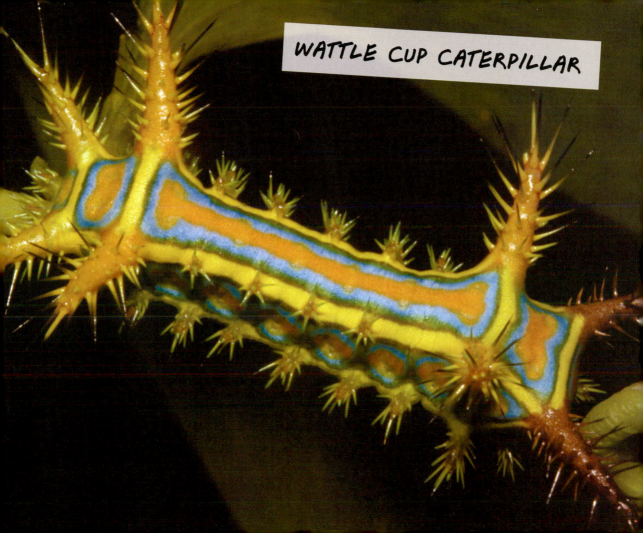

WATTLE CUP CATERPILLAR

PEACOCK MANTIS SHRIMP

Evolution doesn't like to talk about it much, but kids used to make fun of it at school.

"Oh, yeah?" it would say back then. "Yeah, just you wait. One day I'm going to make an animal that's all the colors of the rainbow and has, like, sixteen arms, and one of those arms is going to punch you so hard that it vaporizes water."

And then Evolution did.

The peacock mantis shrimp punches so quickly and with such force that it releases shockwaves that can crack open a fish's skull. Seriously, do not mess with these guys.

BANDED PIGLET SQUID

The piglet squid would seem to suggest that Evolution's medications are working. **Possibly a little too well.**

A band of colored cells called chromatophores are what make the banded piglet squid look smiley. (Well, that and all the drugs.)

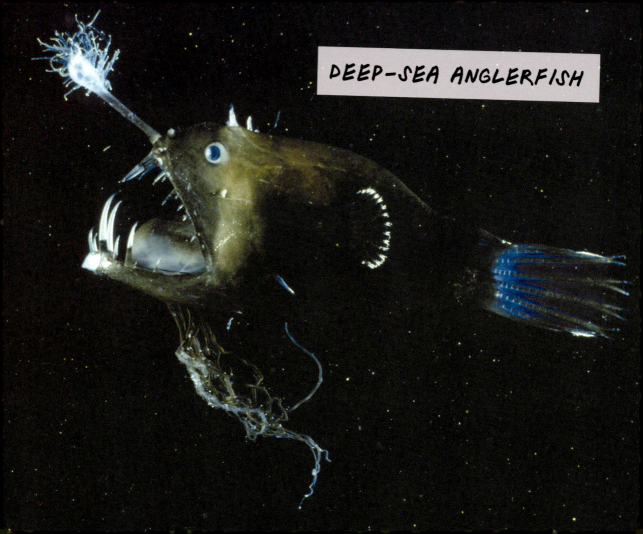

DEEP-SEA ANGLERFISH

"Ahh!"

"What's wrong, Evolution?"

"Oh god, it was so terrible."

"What? Were you dreaming?"

"I saw a fish . . . a horrible fish . . ."

"What was it like?"

"It had these big, piercing eyes."

"Uh huh."

"And huge, razor-sharp fangs."

"That does sound scary."

"And a scraggly, glowing beard."

"Okay, that's weird."

"And it was just drifting through this pitch-black nothingness, all lit up all over like a . . . like an alien spaceship!"

"That sounds really creepy, but it was just a nightmare, Evolution. You can go back to sleep."

"What? No way! I have to make one now."

"Seriously? I do not understand you at all."

> When a male anglerfish finds a mate, he bites onto her skin and gradually fuses with her body, feeding off her blood and continually fertilizing her eggs for the rest of his natural life. Don't ever say that Evolution doesn't believe in commitment.

"I made a new dance!"

"Oh, great."

"So first you kick your third legs into the air, like this."

"My third legs?"

"And then you flip up your colorful butt flap."

"Evolution, I don't have a colorful butt flap."

"Just go with it, okay? Then you kind of waggle the flap back and forth, like this—but really, really fast!—and bend the legs up and down like you're directing traffic."

"Okay, that looks weird."

"Then you just kind of vibrate all over."

"Have you totally lost it?"

"Hey, the lady spiders are super into this."

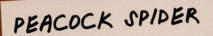

Scientists have dubbed the male peacock spider's rapid abdominal vibrations the "rumble-rump." Sexy.

Evolution didn't want anyone to mess with this caterpillar. That's why it made it look like a . . . like a . . . hmm, wait. Hey, Evolution, this caterpillar actually kind of looks like **a delicious gummy candy.** *Did you get the munchies while you were working?*

The jewel caterpillar's gelatinous coating pulls off easily when touched, leaving a would-be predator with a mouthful of goo while the caterpillar lives to ooze another day.

JEWEL CATERPILLAR

GUIANAN COCK-OF-THE-ROCK

Sometimes Evolution has terrifying fever dreams where everything is beautiful, but nothing makes any sense. Shapes and colors appear and disappear and rearrange themselves like mad ghosts, and nothing ends up quite where it's supposed to be. What do these dreams mean? Evolution doesn't know. But when it wakes up in the morning, *it makes some really weird-ass birds.*

While foraging for fruits, the Guianan cock-of-the-rock makes a call like a duck being strangled. Its closest relative, the Andean cock-of-the-rock, looks like an angry Muppet. They sure did get lucky with the gene pool.

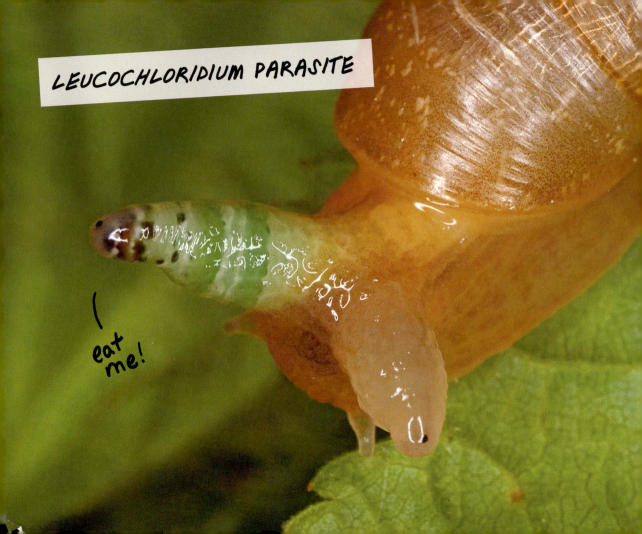

"*Loooook at all the colors.*"

"*Evolution, what are you doing?*"

"Shh! I'm trying to learn hypnosis."

"*What? Why?*"

"I need to trick crows into eating the parasite larvae I grew in this snail's eye-stalk. They need to get into a bird's gut to mature. *Look into the pulsating eye of the snail. Look at it.*"

"*Evolution, this isn't working.*"

"Look closer. **Doesn't it look delicious?**"

"*What? No, it looks disgusting.*"

"Yeah, okay, but **pretend you're a bird.**"

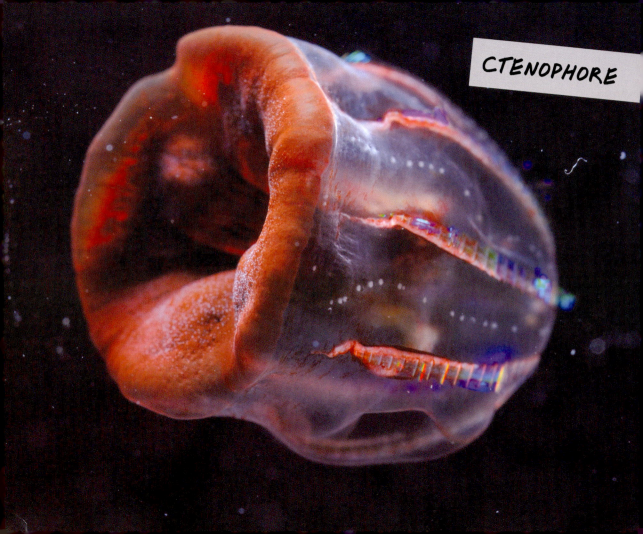

CTENOPHORE

Ctenophores: Because sometimes Evolution only feels like making the mouth.

Although ctenophores do have a rear opening, they usually just poop through their mouths. Before you judge, remember that they're your elders: After recently sequencing the ctenophore genome, some scientists think they were the first multicellular animals on earth.

WEEDY SEA DRAGON

"Hey, Evolution, are you okay?"

"Yeah, I'm just . . . burned out, I guess."

"What do you mean?"

"There's just so much pressure sometimes. 'Oh, Evolution, make a thing that can survive in the desert.' 'Evolution, make a thing that can eat these dead animals' bones.' 'Evolution, make a thing that can live perfectly happily *on the side of a freakin' underwater volcano.*' It never ends."

"I mean, you did an okay job with those, though."

"And then, when I make them, everyone's so picky. Natural Selection, Sexual Selection— everybody has an opinion about what my stuff should look like. 'Change this! Change that! Make this part longer! Or they're all going to die alone and childless.' For Christ's sake."

"Yeah, I guess I never thought about it like that."

"So you know what? I'm tired of listening to everyone else. I'm tired of caving to whatever

stupid selective pressure happens to come along. I'm going to make something that's just how I like it—just for me."

"That's a great idea, Evolution. So what are you going to put on it?"

"Oh, you know, polka dots and weird dangly bits."

"Okay. This is it. I just came up with the greatest animal yet."

"This should be good."

"It's called a tardigrade. It's only half a millimeter long, so it's *basically* invisible."

"I see."

"It has sharp claws for grabbing onto anything and a suction mouth for feeding."

"Seems reasonable."

"But here's the cool part: It can survive pretty much anything! Drying out? Freezing? Extreme radiation? It doesn't care. It just hunkers down and waits it out, then pops back to life later on."

"Huh. I guess that is kind of cool."

"And it can even survive in the vacuum of outer space."

"What? Why would it possibly need to survive in outer space?"

"*You never know.*"

Tardigrades can enter into a state of suspended animation called cryptobiosis, which is effectively a reversible death. Zombies, take note.

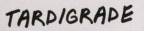

TARDIGRADE

NUDIBRANCHS: EVOLUTION'S ALL-OUT BENDER

"Uuuurrrnnnggghhhhh."

"You feeling okay, Evolution?"

"I feel awful. I think I partied a little too hard last night. I've got to stop doing that."

"Well, yeah, you're not exactly 21 million years old anymore. Here, have an aspirin."

"Thanks. I just wish I remembered what I—oh. Oh, no."

"What?"

"I think I may have made some animals last night."

"Oh, I'm sure you didn't."

"Then why do I have 'NUDIBRANCH' written on the back of my hand? Oh god, what does that even mean?"

"Just get some rest, okay? I'm sure you can sort it out later."

"This is so embarrassing."

Family Tree of Hallucinations

SPANISH SHAWL
Flabellina iodinea

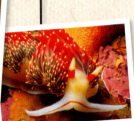

PUGNACIOUS AEOLID
Phidiana hiltoni

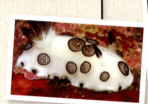

DOTTED NUDIBRANCH
Jorunna funebris

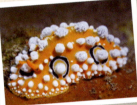

OCELLATE PHYLLIDIA
Phyllidia ocellata

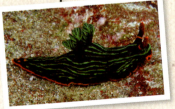

DUSKY NEMBROTHA
Nembrotha kubaryana

The Nose Sessions

Evolution's got a lot to manage between respiration, circulation, locomotion, digestion, pooping, and sex. It can all get a little monotonous, to be frank. But there's one aspect of body planning where Evolution always takes joy in its work: making the nose.

It doesn't matter if it's a flexible proboscis, a beaklike rostrum, or a supersensitive sniffing organ. When it comes to crafting facial protuberances, Evolution goes all out. It makes pointy ones, inflatable ones, curly ones, folded ones, and ones that seem to serve no purpose except to be bizarre.

Who knows why Evolution is so fixated on this one prominent part? Maybe noses remind it of the pungent ammonia smells that filled the air during its younger, Precambrian days, or the hearty aroma of its mother's primordial soup. Maybe it wishes it had a nose itself. Maybe it's been a long few million years, and it's suffered a couple of unfortunate extinctions lately, and after eons of paying strict attention to all the minute bits and pieces that make an organism work, the nose is where Evolution can finally cut loose.

SPOTTED UNICORNFISH

"I'm afraid that this fish is too boring."

"It looks fine, Evolution. It's a fish."

"Really? I just feel like I've done so many fish like this—eyes, mouth, gills, fins, *blah*."

"That's really all it needs. It's a fish."

"But . . . I don't know. I don't like it."

"Don't you have other things you need to work on?"

"Hey, can I do a nose? I love doing noses."

"Sure, Evolution, whatever."

Evolution accidentally dropped this bat on the floor but was too embarrassed to say anything so just pretended it was actually supposed to look like that.

STRIPED LEAF-NOSED BAT

Leaf-nosed bats' nasal folds act like megaphones to amplify the high-frequency sounds they use to hunt. Their giant ears make excellent receiver dishes—but they're still pretty embarrassing on school picture day.

Sometimes Evolution gets confused and puts things that look like creepy baby fingers where your face is supposed to be. Hey, at least it didn't do noses on the hands, right?

When it's digging, the star-nosed mole folds its tentacles inward to keep the soil out of its nostrils. Nothing like a little swamp dirt up your nose to ruin your day.

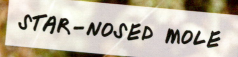

STAR-NOSED MOLE

SOUTHERN ELEPHANT SEAL

Don't mind if I do.

"You know that elephant seal I made? The one with the awesome, floppy, inflatable nose?"

"Yes, Evolution, that was a pretty good nose."

"And you know how it kept getting parasites up inside it?"

"I heard that was an issue."

"I fixed it."

"You fixed it? What did you do, give the seal more protective mucus? A better immune system? Stronger nose hairs?"

"Nope! That all seemed too hard. I just made a nose-picking bird."

"A nose-picking bird."

"Works great!"

"Good lord, Evolution, what is that?"

"It's a 'tapir.' Get it?"

"No."

"A *tapir*."

"I don't get it."

"Come on! A TAPIR!"

"This isn't helping."

"It's a *tapir*! It has a *tapered* nose! *Tapir*!"

"You're unbearable."

The nose isn't the tapir's only impressive organ: The male also has an exceptionally large, surprisingly maneuverable penis, which is about as long as one of his legs.

LANTERN BUG

Lantern bugs got their name from the mistaken eighteenth-century belief that their snouts glowed in the dark. They don't, and it's not clear what else they're good for, either, though they may help the bugs evade predators simply by confusing the hell out of them.

*Look, Evolution, I get it. You probably want to disguise this bug so no one realizes it's a tasty snack. But, come on, **a fake nose?** Isn't that a little . . . obvious?*

Come on, Evolution, you cannot be serious with this sh—

Oh, wait. OH. Ha! I get it.

Clearly, the red-lipped batfish is a work of satire, not meant to be taken as a literal "animal," which would of course be ridiculous. Sorry, I can be a bit slow sometimes. Nice one.

Beneath the batfish's noselike protuberance dangles a small, retractable lure. Scientists aren't sure exactly how the fish uses the lure—nor have they had the heart to tell it that it looks like a giant booger.

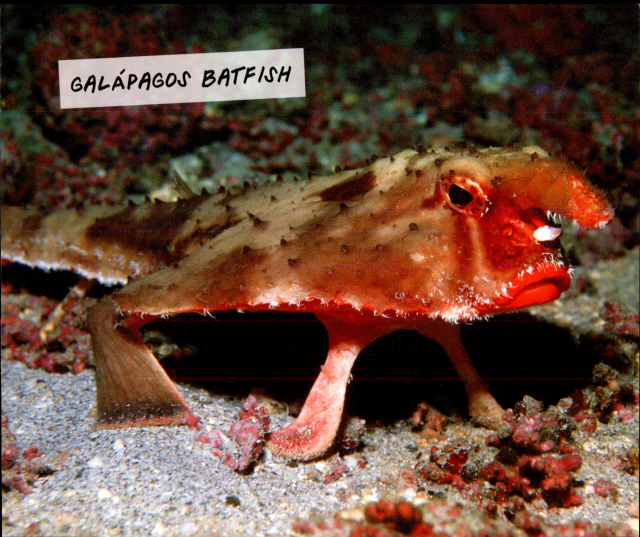

GALÁPAGOS BATFISH

The Pinocchio frog has strong hind legs for leaping, sticky feet for clinging to leaves, bulbous eyes for seeing all around, and a pointy, inflatable nose for . . . umm . . . for . . . okay, fine, nobody's sure what the pointy, inflatable nose is for. Knowing Evolution, though, it's probably some weird sex thing.

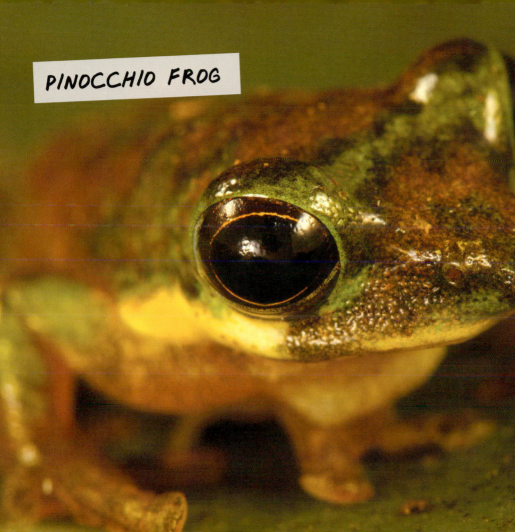

PINOCCHIO FROG

RHINOCEROS CHAMELEON

"Remember that sawfish I did?"

"How could I forget?"

"Well, I liked that one so much, I was thinking, *What if I put the same kind of thing on a chameleon?*"

"On a chameleon? Uh, Evolution . . ."

"Yeah, but maybe even cooler, like, a *chainsaw* this time."

"Are you a gradual process of change and diversification or are you a freaking Home Depot?"

The horn of the rhino chameleon is more prominent in males, which means they may use it to fight with each other. Typical, Evolution.

"New idea!"

"Mm hmm."

"Floppy, inflatable nose . . .

on an antelope!"

"Evolution, are you taking this seriously at all?"

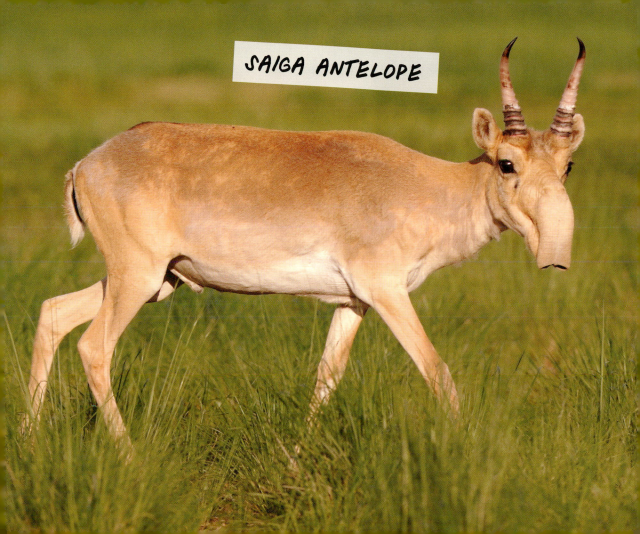

SAIGA ANTELOPE

What's the deal with this snake, Evolution? Did you need something to clean the dirt out of the cracks in your bathroom tiles?

NORTHERN LEAFNOSE SNAKE

Okay, now you're just joking, right? I mean, you're not actually putting a bat out into the world with a nose like this. It's all just a big, hilarious prank, and you're going to go put a normal nose on it any minute now.

Right, Evolution? Because this isn't its real nose.

Evolution?
Right?

TUBE-NOSED
FRUIT BAT

GOLDEN SNUB-NOSED MONKEY

"Damn it! I ran out of noses. Maybe I shouldn't have put so many on the fish."

"There's another shipment coming in next week, Evolution. Just wait until then."

"But I'm already behind deadline on these monkeys! Natural Selection's really been riding me lately. If I hold these up any longer, I'm toast."

"You can't send them out without noses, though! It's grotesque."

"I don't think I have a choice, okay? I really need this job."

Feeling down, dreary, unexcited about life? Attracting fewer mates than a bird-of-paradise with no tail? Ever thought about changing your scent?

Now you can smell dark and mysterious, like the sea.* Introducing . . .

AMBERGRIS

by Evolution

*Specifically, like the ailing bowels of a 100,000-pound seagoing mammal.

ONLY THE FINEST

Ambergris begins deep in the digestive tract of a very special sperm whale. As the whale feasts on thousands upon thousands of delectable deep-ocean squid, a few rigid, indigestible squid parts pass all the way through the whale's four stomachs and slip into its churning intestine. They make their way down to the hindgut, where they mix with the most luxurious liquid fecal matter and are shaped into a ball that builds up slowly, layer by layer, in the whale's voluminous rectum. This is ambergris.

Eventually, the whale dies, sharks shred its carcass, and the massive marble tumbles out into the open sea. When it washes ashore decades later, we find it, grind it into a powder, and put it in a bottle— just for you.

WHY AMBERGRIS?

Ambergris itself is exceedingly rare—forming in the guts of only one out of one hundred sperm whales— and it has some rare properties, too. When mixed into perfume, it not only adds a sweet, alluring scent, but also helps the fragrance linger on your skin for hours on end. Some even say that it's an aphrodisiac. That's why it's been highly prized and sought after for hundreds of years. Now, you can have some of this powerful intestinal secretion for yourself!*

ORDER NOW!

Only $9,999.99 a bottle.

*Offer subject to availability. Aphrodisiac properties not guaranteed.

EVOLUTION:
THE FINAL INTERVIEW

Thanks so much for taking the time to do this, Evolution. So, first off, you've been at this a while now—more than 3.8 billion years.

Ah, jeez, has it really been that long? I could have sworn that the Paleoarchean era was yesterday. Man, that makes me feel old.

Sorry about that. But is there anything big that you've learned in that time?

I guess I've learned to roll with the punches a bit. I can't really depend on anything to stay the same—there are always going to be volcanoes, ice ages, space rocks. . . . You just have to get used to it. After my first couple of mass extinctions, you know, I was pretty devastated. I almost didn't want to keep going. But I've since figured out that the bright side to so many organisms dying off—I mean, apart from all the free food for the scavengers—is that it's an opportunity to get in there and make lots of newer, weirder things. You just have to learn to adapt.

Be honest. Are humans your proudest accomplishment?

What? Oh, god, no. Not at all. I mean, I like people just fine, don't get me wrong—they came out reasonably well for four-legged animals who decided to stand upright at the last minute. By the way, if I'd known that humans were going to

walk on two legs eventually, I would have engineered them much differently from the beginning—those quadruped spinal columns were never really meant to bear vertical loads, you know, and I had to reorient the entire primate pelvis to make everything work. Could have saved people a whole lot of lower back pain if I'd done it from scratch, not to mention most of that hassle with childbirth. Oh, well! Tough break, guys.

Anyway. What was the question? Oh, right. No, humans are far from my proudest accomplishment. You know what I'm *really* pleased with? Tardigrades. I've made more than a thousand species of those microscopic little buggers, and every single one of them is awesome. Did I mention they can survive *in outer space*? So cool.

What's the one thing that people misunderstand about you most?

That's hard to say—they seem to misunderstand a lot of things, for a species with gigantic brains (you're welcome for those, by the way). But I guess it really bothers me when they seem to think that all the other stuff I've made was some kind of practice leading up to them. It really wasn't. Humans just sort of happened, like everything else—and frankly, they've been interfering a little more than I'd like with the rest of my work lately.

What would you want to say to them?

Don't take yourselves so seriously. Look, you're basically giant worms with some slightly fancier accessories surrounding your poop-tubes. Never forget it.

Okay. I really hope you can answer this one, because I think a lot of us are wondering: What were you really thinking with some of these creatures? I mean, the marabou stork? The tube-nosed bat? The PIGBUTT WORM?

Yeah, I can't answer that.

What? Come on. Not even a hint?

Okay, look. Here's what I've realized. I make organisms, right? And I make other organisms for those organisms to eat. Then I make bigger organisms that eat the first organisms, and so on and so forth. It's all just life eating other life, back and forth, round and round, for millions of years on end. And for what? I mean, when you get right down to it, what I've created is basically an unnecessarily complicated system for moving carbon molecules around.

So yeah, I could just make some plain stuff, have it eat some other plain stuff, and then call it an eon and go home. But you know what? It's been billions of years. I get bored just like anyone else. And because everything is just going to keep changing, and it's all a little pointless to begin with—well, why shouldn't I just do whatever I want?

Wow. Actually, that's kind of a nice way of looking at it.

I'm glad you think so. Now if you'll excuse me, I have some work I need to get back to. Those noses aren't going to inflate themselves.

APPENDIX (AN ACTUALLY USEFUL ONE)

All conservation statuses are according to the IUCN Red List of Threatened Species, November 2013 update. Species that have not been evaluated by the IUCN are listed as "Unassessed."

DALMATIAN PELICAN
Scientific name: *Pelecanus crispus*
Habitat: Freshwater wetlands in eastern Europe and east-central Asia
Conservation status: Vulnerable

PEACOCK FLOUNDER
Scientific name: *Bothus mancus*
Habitat: Sandy bottoms of coral reefs in the tropical Indian and Pacific Oceans
Conservation status: Least concern

GIANT THREE-HORNED CHAMELEON
Scientific Name: *Trioceros deremensis*
Habitat: Usambara Mountains of Tanzania
Conservation status: Unassessed

GIRAFFE
Scientific name: *Giraffa camelopardalis*
Habitat: Dry savanna regions of sub-Saharan Africa
Conservation status: Least concern

STALK-EYED FLY
Scientific name: *Teleopsis whitei*
Habitat: Forested ravines in Malaysia
Conservation status: Unassessed

MAGNIFICENT FRIGATEBIRD
Scientific name: *Fregata magnificens*
Habitat: Coastal waters in the tropical and subtropical Pacific and Atlantic Oceans
Conservation status: Least concern

GALÁPAGOS MARINE IGUANA
Scientific name: *Amblyrhynchus cristatus*
Habitat: Rocky coasts of the Galápagos Islands of Ecuador
Conservation status: Vulnerable

PLAINS ZEBRA
Scientific name: *Equus quagga*
Habitat: Grasslands of eastern Africa
Conservation status: Least concern

SHARP-RIBBED NEWT
Scientific name: *Pleurodeles waltl*
Habitat: Ponds, lakes, and ditches in Spain, Portugal, and northern Morocco
Conservation status: Near threatened

MARABOU STORK
Scientific name: *Leptoptilos crumeniferus*
Habitat: Grasslands and wetlands of sub-Saharan Africa
Conservation status: Least concern

GREAT BLUE-SPOTTED MUDSKIPPER
Scientific name: *Boleophthalmus pectinirostris*
Habitat: Coastal mud flats in China, Korea, and Japan
Conservation status: Unassessed

GIRAFFE-NECKED WEEVIL
Scientific name: *Trachelophorus giraffa*
Habitat: Rain forest of Madagascar
Conservation status: Unassessed

SARCASTIC FRINGEHEAD
Scientific name: *Neoclinus blanchardi*
Habitat: Waters 10–200 feet deep along the coasts of California and northern Mexico
Conservation status: Unassessed

KAYAN SLOW LORIS
Scientific name: *Nycticebus kayan*
Habitat: Lowland forests of Indonesia, Malaysia, and southern Thailand
Conservation status: Unassessed

SURINAM HORNED FROG
Scientific Name: *Ceratophrys cornuta*
Habitat: Forested areas in the Amazon Basin of South America
Conservation Status: Least concern

OCEAN SUNFISH
Scientific Name: *Mola mola*
Habitat: Temperate and tropical ocean waters
Conservation Status: Unassessed

ATLANTIC SAND FIDDLER
Scientific Name: *Uca pugilator*
Habitat: Sandy beaches along the East Coast of the U.S.
Conservation Status: Unassessed

RIBBON EEL
Scientific Name: *Rhinomuraena quaesita*
Habitat: Coral reefs in the tropical Indian and Pacific Oceans
Conservation Status: Least concern

ASIAN GIANT SOFTSHELL TURTLE
Scientific Name: *Pelochelys cantorii*
Habitat: Freshwater lakes, rivers, and coasts in Southeast Asia
Conservation Status: Endangered

DUMBO OCTOPUS
Scientific Name: *Grimpoteuthis* sp.
Habitat: 1,500 to 15,000 feet deep in oceans all over the world
Conservation Status: Unassessed

PAINTED FROGFISH
Scientific Name: *Antennarius pictus*
Habitat: Shallow, sheltered reefs in the Indian and Pacific Oceans
Conservation Status: Unassessed

SECRETARY BIRD
Scientific Name: *Sagittarius serpentarius*
Habitat: Open woodlands and savannas of sub-Saharan Africa
Conservation Status: Vulnerable

BOXER CRAB
Scientific Name: *Lybia tessellata*
Habitat: Coral reefs in the Indian and western Pacific Oceans
Conservation Status: Unassessed

PIGNOSE FROG
Scientific Name: *Nasikabatrachus sahyadrensis*
Habitat: Wet forests in the Western Ghat Mountains of southern India
Conservation Status: Endangered

IRRAWADDY DOLPHIN
Scientific Name: *Orcaella brevirostris*
Habitat: Coastal waters, rivers, and lakes in Indonesia, the Philippines, Thailand, and India
Conservation Status: Vulnerable

SEA POTATO
Scientific Name: *Echinocardium* sp.
Habitat: Sandy shore waters of oceans around the world
Conservation Status: Unassessed

WHITEMARGIN STARGAZER
Scientific Name: *Uranoscopus sulphureus*
Habitat: Sandy bottoms of tropical reefs
Conservation Status: Unassessed

REGAL HORNED LIZARD
Scientific Name: *Phrynosoma solare*
Habitat: Sonoran Desert of the southwestern U.S. and northwestern Mexico
Conservation Status: Least concern

PRAYING MANTIS
Scientific Name: *Mantis religiosa*
Habitat: Trees and shrubs in Europe and northern Africa
Conservation Status: Unassessed

BALD UAKARI
Scientific Name: *Cacajao calvus*
Habitat: Seasonally flooded forests of the western Amazon
Conservation Status: Vulnerable

PACIFIC HATCHETFISH
Scientific Name: *Argyropelecus affinis*
Habitat: 1,000–2,000 feet deep in oceans all over the world
Conservation Status: Unassessed

KING VULTURE
Scientific Name: *Sarcoramphus papa*
Habitat: Lowland forests in Central and South America
Conservation Status: Least concern

VISAYAN WARTY PIG
Scientific Name: *Sus cebifrons*
Habitat: Forests of the West Visayan Islands in the Philippines
Conservation Status: Critically endangered

SMALLTOOTH SAWFISH
Scientific Name: *Pristis pectinata*
Habitat: Near the shore in tropical and temperate ocean waters
Conservation Status: Critically endangered

SHOEBILL
Scientific Name: *Balaeniceps rex*
Habitat: Swamps of eastern Africa
Conservation Status: Vulnerable

GUM LEAF SKELETONIZER CATERPILLAR
Scientific Name: *Uraba lugens*
Habitat: Forests and tree plantations in Australia and New Zealand
Conservation Status: Unassessed

REEF STONEFISH
Scientific Name: *Synanceia verrucosa*
Habitat: Reefs and lagoons in the tropical Indian and Pacific Oceans
Conservation Status: Unassessed

GUNNISON SAGE GROUSE
Scientific Name: *Centrocercus minimus*
Habitat: Sagebrush-dominated grasslands of Colorado and southeastern Utah
Conservation Status: Endangered

TONGUE-EATING ISOPOD
Scientific Name: *Cymothoa exigua*
Habitat: The mouths of fishes in the eastern Pacific Ocean
Conservation Status: Unassessed

SAND CAT
Scientific Name: *Felis margarita*
Habitat: Sand dunes of northern Africa and the Middle East
Conservation Status: Near threatened

PROBOSCIS MONKEY
Scientific Name: *Nasalis larvatus*
Habitat: Forests and swamps of the island of Borneo
Conservation Status: Endangered

TEMMINCK'S TRAGOPAN
Scientific Name: *Tragopan temminckii*
Habitat: Forests of south-central China and the eastern Himalayas
Conservation Status: Least concern

SURINAM TOAD
Scientific Name: *Pipa pipa*
Habitat: Swamps and ponds of the Amazon Basin in South America
Conservation Status: Least concern

LEOPARD SEA CUCUMBER
Scientific Name: *Bohadschia argus*
Habitat: Coral reefs in the southwest Pacific and far eastern Indian Oceans
Conservation Status: Least concern

INDIAN BALLOON FROG
Scientific Name: *Uperodon globulosus*
Habitat: Damp soils in India and Bangladesh
Conservation Status: Least concern

LEOPARD SLUG
Scientific Name: *Limax maximus*
Habitat: Fields, woods, and gardens all over the world
Conservation Status: Unassessed

EISELT'S CAECILIAN
Scientific Name: *Atretochoana eiselti*
Habitat: Warm, muddy rivers in the Brazilian Amazon Basin
Conservation Status: Unknown (data deficient)

YELLOW-FOOTED ANTECHINUS
Scientific Name: *Antechinus flavipes*
Habitat: Forests and swamps of eastern and southwestern Australia
Conservation Status: Least concern

PIGBUTT WORM
Scientific Name: *Chaetopterus pugaporcinus*
Habitat: 3,400 feet deep in Monterey Bay, California
Conservation Status: Unassessed

VERVET MONKEY
Scientific Name: *Chlorocebus pygerythrus*
Habitat: Savannas and woodlands in eastern and southern Africa
Conservation Status: Least concern

WESTERN GRAY KANGAROO
Scientific Name: *Macropus fuliginosus*
Habitat: Woodlands and grasslands in southern Australia
Conservation Status: Least concern

PACIFIC GEODUCK
Scientific Name: *Panopea generosa*
Habitat: Coastal tide flats in the Pacific Northwest U.S. and British Columbia
Conservation Status: Unassessed

OKAPI
Scientific Name: *Okapia johnstoni*
Habitat: Dense tropical forests in the Democratic Republic of the Congo
Conservation Status: Endangered

MALLARD
Scientific Name: *Anas platyrhynchos*
Habitat: Freshwater lakes, marshes, and streams throughout the Northern Hemisphere
Conservation Status: Least concern

PACIFIC HAGFISH

Scientific Name: *Eptatretus stoutii*
Habitat: Muddy and sandy seabeds along the northeastern Pacific coast
Conservation Status: Unknown (data deficient)

ACORN BARNACLE

Scientific Name: *Balanus glandula*
Habitat: Rocky shores of western North America
Conservation Status: Unassessed

HORNED GUAN

Scientific Name: *Oreophasis derbianus*
Habitat: High-altitude humid forests of Guatemala and southern Mexico
Conservation Status: Endangered

BABIRUSA

Scientific Name: *Babyrousa babyrussa*
Habitat: Tropical rain forests of Indonesia
Conservation Status: Vulnerable

FLANNEL MOTH CATERPILLAR

Scientific Name: *Megalopyge* sp.
Habitat: Trees of the southern U.S. and Central and South America
Conservation Status: Unassessed

GERENUK

Scientific Name: *Litocranius walleri*
Habitat: High deserts and treeless plains in the horn of eastern Africa
Conservation Status: Near threatened

YETI CRAB
Scientific Name: *Kiwa hirsuta*
Habitat: Deep-sea hydrothermal vents along the Pacific-Atlantic ridge
Conservation Status: Unassessed

SHINGLEBACK SKINK
Scientific Name: *Tiliqua rugosa*
Habitat: Grasslands and shrublands of southern Australia
Conservation Status: Unassessed

BEARDED PIG
Scientific Name: *Sus barbatus*
Habitat: Forests of Malaysia and Indonesia
Conservation Status: Vulnerable

CORDYCEPS FUNGUS
Scientific Name: *Cordyceps* sp.
Habitat: The bodies of arthropods in tropical and temperate regions
Conservation Status: Unassessed

ATLANTIC WOLFFISH
Scientific Name: *Anarhichas lupus*
Habitat: Shallow, rocky seabeds in the northern Atlantic Ocean
Conservation Status: Unassessed

EMEI MUSTACHE TOAD
Scientific Name: *Leptobrachium boringii*
Habitat: Forested valleys in mountainous regions of central China
Conservation Status: Endangered

SPRINGBOK
Scientific Name: *Antidorcas marsupialis*
Habitat: Southern African grasslands
Conservation Status: Least concern

PLANTHOPPER NYMPH
Scientific Name: Lophopidae family
Habitat: Woody plants in the tropics
Conservation Status: Unassessed

TASSELLED WOBBEGONG
Scientific Name: *Eucrossorhinus dasypogon*
Habitat: Shallow coral reefs in Indonesia, Papua New Guinea, and northern Australia
Conservation Status: Near threatened

PING-PONG TREE SPONGE
Scientific Name: *Chondrocladia lampadiglobus*
Habitat: Near active volcanic vents 9,000 feet deep in the eastern Pacific Ocean
Conservation Status: Unassessed

LONG-HORNED ORB WEAVER
Scientific Name: *Macracantha arcuata*
Habitat: Forests of Southeast Asia
Conservation Status: Unassessed

DUCK-BILLED PLATYPUS
Scientific Name: *Ornithorhynchus anatinus*
Habitat: Rivers, lakes, and streams in eastern Australia
Conservation Status: Least concern

NARWHAL
Scientific Name: *Monodon monoceros*
Habitat: Cold, deep Arctic waters
Conservation Status: Near threatened

RED HANDFISH
Scientific Name: *Thymichthys politus*
Habitat: Seabeds near shores in southern Australia and Tasmania
Conservation Status: Unassessed

MANDRILL
Scientific Name: *Mandrillus sphinx*
Habitat: Evergreen rain forests in central west Africa
Conservation Status: Vulnerable

MIRROR SPIDER
Scientific Name: *Thwaitesia* sp.
Habitat: Tropical regions around the world
Conservation Status: Unassessed

HAIRY SQUAT LOBSTER
Scientific Name: *Lauriea siagiani*
Habitat: Coral reefs of Indonesia, Japan, and the Philippines
Conservation Status: Unassessed

WATTLE CUP CATERPILLAR
Scientific Name: *Calcarifera ordinata*
Habitat: Dogwood and acacia trees in northern Australia
Conservation Status: Unassessed

PEACOCK MANTIS SHRIMP
Scientific Name: *Odontodactylus scyllarus*
Habitat: Gravelly reef bottoms in the Indian and Pacific Oceans
Conservation Status: Unassessed

BANDED PIGLET SQUID
Scientific Name: *Helicocranchia pfefferi*
Habitat: Up to 6,500 feet deep in the Pacific and Atlantic Oceans
Conservation Status: Unassessed

DEEP-SEA ANGLERFISH
Scientific Name: *Linophryne arborifera*
Habitat: 3,000–10,000 feet deep in the Atlantic Ocean
Conservation Status: Unassessed

PEACOCK SPIDER
Scientific Name: *Maratus volans*
Habitat: Near the coast of New South Wales, Australia
Conservation Status: Unassessed

JEWEL CATERPILLAR
Scientific Name: *Acraga coa*
Habitat: Forests of Central America
Conservation Status: Unassessed

GUIANAN COCK-OF-THE-ROCK
Scientific Name: *Rupicola rupicola*
Habitat: Humid forests in northeastern South America
Conservation Status: Least concern

LEUCOCHLORIDIUM PARASITE
Scientific Name: *Leucochloridium paradoxum*
Habitat: The eyestalks of snails and the intestines of birds
Conservation Status: Unassessed

CTENOPHORE
Scientific Name: *Bathyctena chuni*
Habitat: More than 5,900 feet deep in the Pacific Ocean
Conservation Status: Unassessed

WEEDY SEA DRAGON
Scientific Name: *Phyllopteryx taeniolatus*
Habitat: Rocky reefs and seaweed beds around Australia
Conservation Status: Near threatened

TARDIGRADE
Scientific Name: *Macrobiotus sapiens*
Habitat: Soil, damp moss, and bodies of water all over the world
Conservation Status: Unassessed

SPOTTED UNICORNFISH
Scientific Name: *Naso brevirostris*
Habitat: Coral reefs in the Indian and Pacific Oceans
Conservation Status: Least concern

STRIPED LEAF-NOSED BAT
Scientific Name: *Hipposideros vittatus*
Habitat: Caves and tree canopies in eastern and southern Africa
Conservation Status: Near threatened

STAR-NOSED MOLE
Scientific Name: *Condylura cristata*
Habitat: Forests, marshes, and stream banks in eastern North America
Conservation Status: Least concern

SOUTHERN ELEPHANT SEAL
Scientific Name: *Mirounga leonina*
Habitat: Oceans and beaches of the Southern Hemisphere
Conservation Status: Least concern

LOWLAND TAPIR
Scientific Name: *Tapirus terrestris*
Habitat: Rain forests and wetlands of South America
Conservation Status: Vulnerable

LANTERN BUG
Scientific Name: *Pyrops candelaria*
Habitat: Fruit trees in southern China
Conservation Status: Unassessed

GALÁPAGOS BATFISH
Scientific Name: *Ogcocephalus darwini*
Habitat: Sandy reef bottoms in the southeast Pacific
Conservation Status: Least concern

PINOCCHIO FROG
Scientific Name: *Litoria* sp.
Habitat: Foja Mountains of Indonesia
Conservation Status: Unassessed

RHINOCEROS CHAMELEON
Scientific Name: *Furcifer rhinoceratus*
Habitat: Deciduous forests of western Madagascar
Conservation Status: Vulnerable

SAIGA ANTELOPE
Scientific Name: *Saiga tatarica*
Habitat: Steppe grasslands and deserts of Mongolia and Kazakhstan
Conservation Status: Critically endangered

NORTHERN LEAFNOSE SNAKE
Scientific Name: *Langaha madagascariensis*
Habitat: Trees of Madagascar
Conservation Status: Least concern

TUBE-NOSED FRUIT BAT
Scientific Name: *Nyctimene* sp.
Habitat: Mountains of Papua New Guinea
Conservation Status: Unassessed

GOLDEN SNUB-NOSED MONKEY
Scientific Name: *Rhinopithecus roxellana*
Habitat: Mountains of southwestern China
Conservation Status: Endangered

SELECTED BIBLIOGRAPHY

For a full list of sources, including research on individual species, please visit maragrunbaum.com/wtfsources

Benton, Michael J. *When Life Nearly Died: The Greatest Mass Extinction of All Time.* London: Thames & Hudson, 2003.

BirdLife Data Zone. BirdLife International, 2013. birdlife.org/datazone

Campbell, Andrew, and John Dawes, eds. *The Encyclopedia of Underwater Life.* Oxford, UK: Oxford University Press, 2005.

The Catalogue of Life. Integrated Taxonomic Information System, 20 January 2014. catalogueoflife.org/col/

Freeman, Scott, ed. *Biological Science.* 3rd ed. San Francisco: Pearson Education, 2008.

Froese, R., and D. Pauly, eds. *FishBase.* December 2013. fishbase.org

Halliday, Tim, and Kraig Adler, eds. *The New Encyclopedia of Reptiles and Amphibians.* Oxford, UK: Oxford University Press, 2002.

Hutchins, Michael, ed. *Grzimek's Animal Life Encyclopedia.* 2nd ed. Vol 1–17. Detroit: Gale, 2003–2004.

The IUCN Red List of Threatened Species. Version 2013.2. International Union for Conservation of Nature and Natural Resources, 2013. iucnredlist.org

Kingdon, Jonathan, et al., eds. *Mammals of Africa.* London: A&C Black, 2013.

Macdonald, David W., ed. *The Encyclopedia of Mammals.* Oxford, UK: Oxford University Press, 2006.

O'Toole, Christopher, ed. *The New Encyclopedia of Insects and Their Allies.* Oxford, UK: Oxford University Press, 2002.

Perrins, Christopher M., ed. *The New Encyclopedia of Birds.* Oxford, UK: Oxford University Press, 2003.

Preston-Mafham, Rod, and Ken Preston-Mafham. *The Encyclopedia of Land Invertebrate Behaviour.* London: Blandford Press, 1993.

Uetz, Peter, and Jirí Hošek, eds. *The Reptile Database.* December 2013. reptile-database.reptarium.cz/

Wake, David B., et al. *AmphibiaWeb: Information on Amphibian Biology and Conservation.* The Regents of the University of California, 2014. amphibiaweb.org

World Register of Marine Species (WoRMS). WoRMS Editorial Board, 2014. marinespecies.org/

PHOTO CREDITS

ACKNOWLEDGMENTS

For encouragement, inspiration, and companionship in times of doubt, my many thanks to Alex Blackwood, Ariel Bleicher, Emily Elert, Ferris Jabr, Olivia Koski, Katie and Josh Peek, and Anna Rothschild. You all fill my four-chambered blood-pumping chest organ with joy.

Thanks to Sasha Grunbaum Lian, an all-around excellent sister and human, for always poking at weird sea creatures with me; to my parents, Galya Diment and Rami Grunbaum, for the support and writing genes; and to my grandparents, the best ancestors a girl could ask for. (Sorry about the title, Grandma.)

For scientific expertise and fact-checking, my infinite gratitude to Pedro S. Baranda, Nicholas Block, Sara Branco, R. Crystal Chaw, Allyson Fenwick, Brooke Flammang, Ryan J. Haupt, Rebecca R. Helm, Tine Huyse, Mary R. Krauszer, Nathan Lord, Michelle Mabry, François Michonneau, Andre Ngo, Will Pitchers, Monique Reed, Michael S. Rosenberg, Maja Šešelj, Valerie Syverson, Paula Teichholtz, Morgan Tingley, Kim Warren, Susan Weiner, and Daniela E. Winkler. If anything is incorrect, though, it's my fault.

Finally, thanks to the citizens of the Internet for reading, sharing, and contributing suggestions to the primordial blog version of this project, and to my agent Rachel Vogel and wonderful editor Liz Davis for believing that it could evolve into a book.

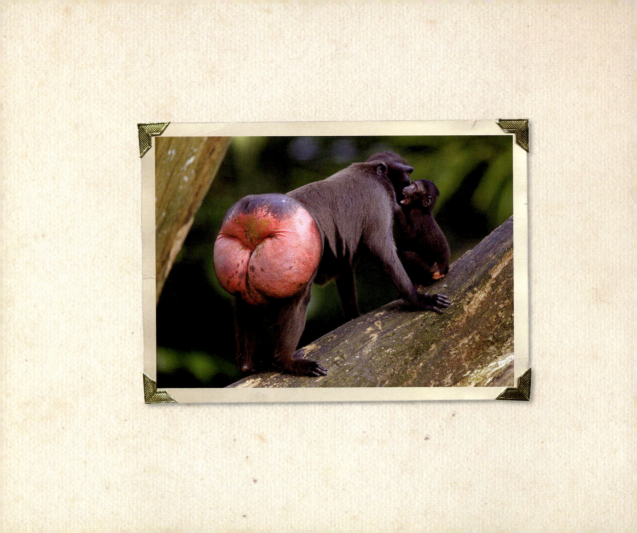